SKILLS
PROJECTS
IDEAS

The Ultimate
DRAWING
WORKBOOK

SKILLS
PROJECTS
IDEAS

The Ultimate
DRAWING
WORKBOOK

BARRINGTON BARBER
PETER GRAY

ARCTURUS

This edition published in 2011 by Arcturus Publishing Limited
26/27 Bickels Yard, 151–153 Bermondsey Street,
London SE1 3HA

Peter Gray wishes to thank the Melford Green Alpaca Farm, Suffolk.

ISBN: 978-1-84837-841-4
AD001773EN

Printed in China

CONTENTS

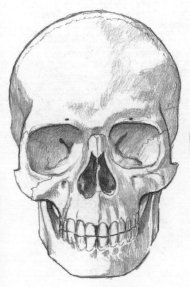
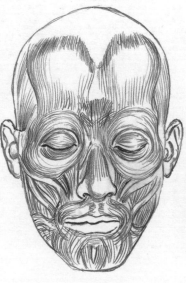
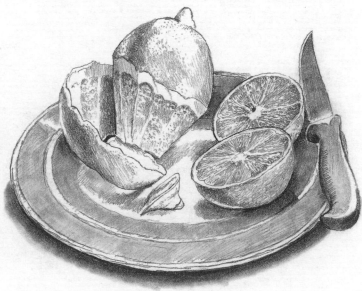

CONTENTS

BASIC MATERIALS AND EQUIPMENT

One of the great things about taking up drawing is that you need very little equipment, and therefore only a small budget, to get started. There is a large and highly profitable industry in artists' materials and some of the elaborate items on show in art shops can be very tempting, but fancy materials and equipment can confuse the issue of learning to draw. To start with you'll need only pencils, paper, an eraser and a knife, but in the Drawing Techniques section we'll look at other materials and tools you might want to experiment with and add to your kit.

Pencils

Although any pencil will do for mastering the basics of drawing, cheap ones can be scratchy and unsatisfying to work with. It's well worth splashing out on a few good-quality pencils from an art supplies shop. They are graded from H (hard) to B (black) with a number prefix indicating the degree of hardness or blackness. A useful starting set would be H, HB, 2B and 6B.

HANDY HINT

Buy pencils of different grades with different coloured shafts so that you can identify them at a glance.

Supports

Many of the exercises in this book can be undertaken on a table top, but for your comfort you may prefer to tilt the drawing surface towards you. Sketchpads usually have a back cover that's rigid enough for them to be usable simply leant against the edge of the table. For working on loose paper, a small drawing board may be useful. A thin sheet of plywood, say 5mm (¼ in), will be strong yet light enough to carry with you for working on location. Make sure it is sanded smooth and slightly larger than your paper, which can be affixed with masking tape at the corners.

Eraser

An eraser is a vital part of your kit. There is absolutely no shame to be felt in erasing mistakes and rough guidelines – they are an important part of the drawing process.

Buy a good-quality eraser that is neither too hard nor too spongy; there are dozens of varieties on the market, but they all do essentially the same job. When the corners wear blunt, an eraser can be trimmed with a knife to produce a fine working edge. For fiddly erasing I often use a special eraser that comes in the form of a pencil and can be sharpened to a point.

BASIC MATERIALS
AND EQUIPMENT

Paper

For your early sketches, virtually any paper will do. A cheap spiral-bound sketchpad, A4 or preferably A3, would be good, but photocopy paper or even scrap paper will be fine. Expensive paper only serves to inhibit your freedom to make mistakes.

As you advance in both skill and ambition, the more important the grade and type of paper becomes: chalks and charcoal work best on a lightly textured surface and some subjects might call for the paper to be toned (see pages 98–9). Wet media, such as watercolour, need thicker paper that won't buckle with moisture. Paper rated anywhere between 200gsm (120lb) and 300gsm (180lb) should be quite heavy enough. For larger drawings, you could use decorators' lining paper, which is very cheap, robust and comes in rolls of 10m (33ft). You may also enjoy experimenting with shiny paper, brown parcel paper or even cardboard as a surface.

Sharpening

A sharp knife or scalpel is essential for fashioning the points of your pencils. For drawing, pencils are ideally sharpened to reveal a good length of lead, unlike the uniform point produced by a pencil sharpener. Keep the blade at an acute angle to the pencil, and always sharpen the pencil away from your body. Soft pencils such as 2B or 6B require regular sharpening, maybe several times in the course of drawing a single picture. A pencil sharpener can be handy for repeatedly honing a point for detailed work.

HANDY HINT

Some pencil sharpeners come within a capsule that collects the shavings. These help you to avoid littering when you're drawing on location.

INTRODUCTION

To the novice or developing artist, the dazzling array of materials in an art shop can be quite bewildering. There is a common misconception that spending a lot of money aids artistic development, but in fact quite the opposite is true. Expensive materials only inhibit the freedom to make mistakes – and mistakes are essential to the processes of learning and developing a creative outlook.

With only a few basic tools and materials, a vast range of techniques and effects is open to you. This section of the book aims to introduce different ways of thinking about commonly used materials which will familiarize you with their various properties and help you to gain proficiency in using them.

For those readers who have yet to become confident draughtsmen, there are some reminders of the basic principles of drawing. Discussions of line, tone, perspective and more will include helpful tips and shortcuts that may also be useful to more accomplished artists.

The best way to instruct is by demonstration. In this section there are examples of techniques broken down into easy-to-follow stages. When following the exercises, try to resist simply copying my examples; apply the same stages to subjects of your own to create new pictures. Think of the techniques shown merely as starting points. You will be encouraged to experiment, push these methods further and devise techniques of your own.

Although technique is but one element of artistic creation, understanding the methods of drawing will enrich your experience of art, both in analysing and appreciating other artists' work and in developing your own personal drawing language.

Peter Gray

BASIC SKETCHING TECHNIQUES

For those readers who have recent experience of drawing, the following techniques should be second nature, but it never does any harm to be reminded of the basic principles.

Unless you have the quick-fire confidence of a master draughtsman, drawing is a process that usually goes through certain stages. Essentially, it involves working from large shapes towards small details, drafting rough guidelines and gradually refining the forms through sight measuring, crosschecking and ever-closer observation.

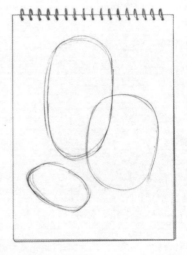

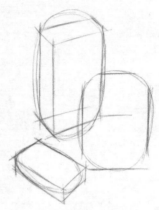

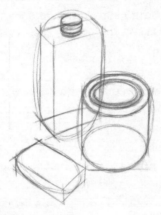

Step 1
Using a hard pencil (H or HB), lightly sketch the general mass of the objects. Make sure that each object is roughly the correct size in relation to the others. Try to fill the paper; working too small will tend to make your drawings tight and stilted from the start.

Step 2
This step is crucial to making a successful drawing. Here you have to map out the essential lengths and angles of the lines that will provide a frame for the rest of the work (see opposite page).

Step 3
Having measured the width and height of the large ellipse, it was quite easy for me to add a smooth curve within the lines already drawn. Drawing a full ellipse for the base of the tin helped me to make the curve smooth and also to check that the tin sits comfortably in front of the oblong tin.

Step 4
A softer pencil (2B), sharpened to a fine point, is good at this stage to strengthen and finalize the good lines.

Step 5
All the scruffy marks, mistakes and guidelines are carefully removed with an eraser. Use the corner of the eraser for detailed work. This is the simplest form of line drawing, showing only outlines and constructional details.

JUDGING THE ANGLES

Vertical lines should be drawn strictly vertically, but other angles can be assessed with the aid of your pencil. Hold it vertically about 30cm (12in) in front of your eyes then tilt it left or right until it lines up with an object. Holding that angle, move the pencil down to the relevant area of your drawing.

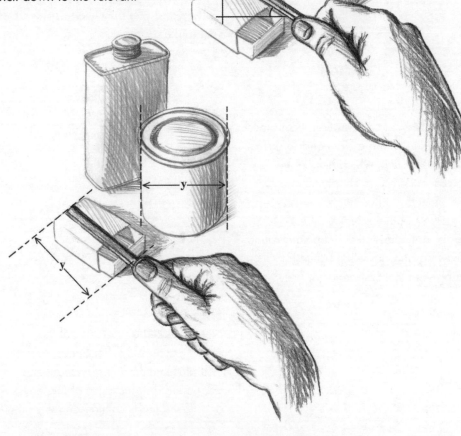

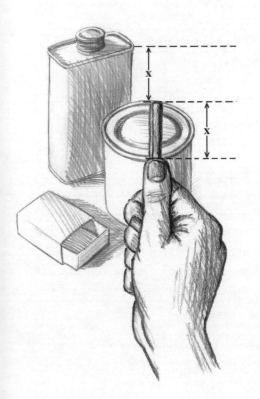

JUDGING PROPORTIONS (SIGHT SIZING)

Your pencil can also be employed as a makeshift ruler. Measure the length of the object as it appears along your pencil and mark the length with your thumb. That measurement can then be used to check the relative lengths of other lines. You can see from my picture that, from my angle of view, the total length of the matchbox is about the same as the width of the round tin. The depth of the large ellipse is about the same as its distance from the corner of the tin above it. Each dimension can be checked against others.

TEXTURED LINE

Lines of different weight and quality, even in an outline drawing, can help to describe objects by conveying something of the surface along with the shape. The suggestion of texture is a subtle yet highly effective means of expression in drawing.

To make a textural still life, gather some objects that are varied in their surfaces and forms. I've chosen to mix organic and man-made objects and keep them within a theme. Whatever objects you choose to draw, there are no definitive rules about what marks you use to describe them. The important thing is that you keep the different surfaces distinct from each other, and you may even find yourself exaggerating the qualities of the marks you make.

Step 1

For a pleasing composition, I arranged my still life within a diamond shape. I drew that first, which helped me to place the rough shapes of the objects. At this stage, I wasn't worried about the leaves of my roses, only the stalks. Keep your rough drawing and guidelines quite faint, using your hardest pencil at first.

Step 2

Next I worked on the form of the objects, constantly checking their size and placement against each other. I added the rough shapes of the leaves and flowerheads coming off the stalks.

Step 3

Once I was happy with the general shapes, it was quite easy for me to refine details. I paid particular attention to the direction of the string wrapping around the ball. Remember that all this work should be drawn quite faintly.

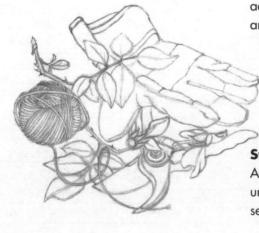

Step 4

At this stage, I cleaned up the drawing as much as possible, carefully erasing any unwanted lines and marks. I also worked on some of the finer details of the string, secateurs and flowerheads.

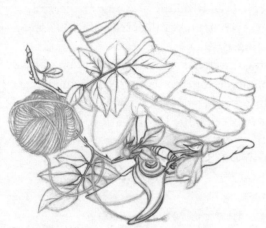

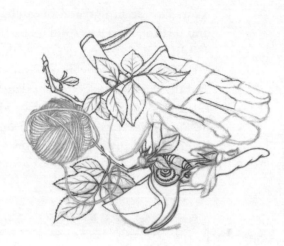

Step 6

After resharpening my pencil, I started to pick out the hard-edged detail. Drawing serrated edges on the leaves gave them the distinctive look of rose foliage without the necessity to observe every serration. I wanted to convey the different fabrics of the glove in the lines of the drawing. Here I have worked on the braid and cloth, suggesting the weave.

Step 5

I started the final line work by defining the hard edges and smooth surfaces. A well-sharpened HB or 2B pencil is suitable for this. Applying firm pressure, in long, flowing strokes, I followed the underdrawing, cleaning up stray lines with the corner of an eraser as I went.

Step 7

For the softer lines a softer pencil was required, so I switched to a 6B and rounded off the point on scrap paper. I used broad, fluffy marks to describe the texture of the suede glove. For the string, I went over the lines several times with short, soft strokes of the pencil, then after a bit of cleaning up, I added a wispy halo effect.

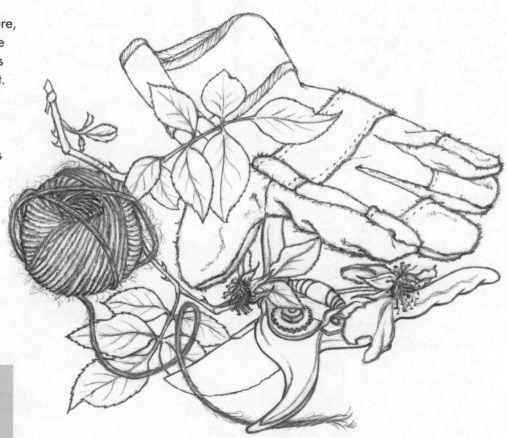

HANDY HINT

It is surprising how much plant material moves as it dries out. There comes a point in a drawing when you have to settle on the shapes and positions of such things.

TONE

As we have seen, a great deal can be conveyed with line drawing: shape, scale and texture, as well as solid form. However, to more fully create the illusion of solidity it is necessary to master shading, or 'tone'.

Understanding tone means analysing the effects of light falling upon objects and the shadows cast by them. The angle, strength and quality of light affect the way an object looks as much as its own shape, texture and colour. Look out of your window: your window frame may be painted white, but against the brightness of the sky, it will appear to be virtually black. When drawing with tone, nothing can be taken for granted.

Presented with the limited information of a line drawing, it is only if we are familiar with objects like these that we are able to deduce their solid forms. Even so, there is much ambiguity: is that a lid on the bottle, or an opening? What material is the box made of? How is the key balanced at such an angle? Is that an orange, or a flat disc?

When working in tone, the composition of the tonal elements within the frame of the picture should be considered. Here I reduced the arrangement to slabs of pure tone to show the balanced dispersal of tone across the picture area and check my composition before getting into detail.

With a full range of tone applied, all our questions are answered; we can clearly see the solid forms of the objects. Shadows cast by objects on to others clarify their placement in relation to each other. The shading tells us about the brightness and direction of light and the surface upon which everything sits. Though the illumination is clearly directed from top left, 'reflected light' is visible on the undersides of objects where light bounces off surrounding surfaces.

Also depicted is the 'local tone' of the objects – that is, their inherent tonal values. Thus, the bottle is slightly darker than the box, the orange mid-toned, and the key much the darkest object. Local tone allows for the presence of 'highlights', which tell us much about surfaces and materials and can give a bit of sparkle to a picture.

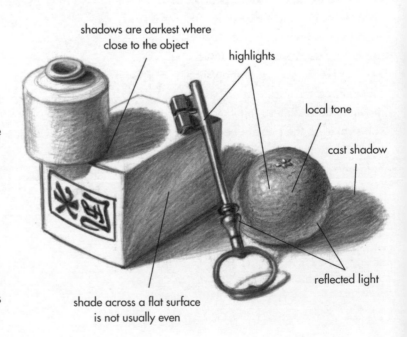

shadows are darkest where close to the object

highlights

local tone

cast shadow

reflected light

shade across a flat surface is not usually even

SHADING PATTERNS

Once you become proficient at analysing and drawing with tone, you may want to experiment with different methods of applying shade.

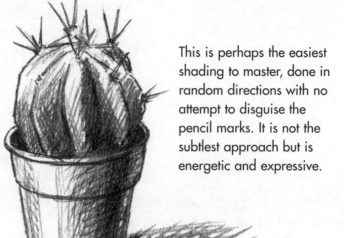

This is perhaps the easiest shading to master, done in random directions with no attempt to disguise the pencil marks. It is not the subtlest approach but is energetic and expressive.

The shading here follows the form, curving around the contours of the subject. This is difficult to achieve, but can be quite effective in helping to describe the shape and depth of objects.

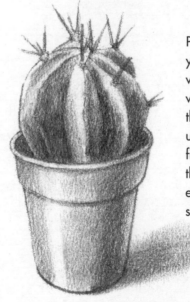

Perhaps you do not want your pencil marks to be visible at all. This picture was shaded with the side of the pencil and the tones built up in painstaking layers. A fingertip can help to blend the tones and an eraser is especially useful to pick out soft highlights.

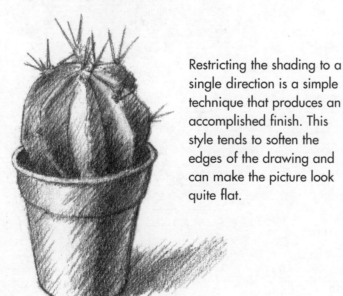

Restricting the shading to a single direction is a simple technique that produces an accomplished finish. This style tends to soften the edges of the drawing and can make the picture look quite flat.

HANDY HINT

In black and white artwork, it is a widely used convention to play down local tone and allow the brightest parts of a subject to remain white. This makes for bold, clearly readable drawings.

TONAL DRAWING

Whatever shading pattern you prefer, whether it is careful rendering or vigorous scrubbing, the principles of drawing in tone are the same. It is about careful observation of the fall of light and interpreting this across the whole picture. It is also important to manage your artwork for clarity, which may involve some elements of exaggeration or invention.

Step 1
As usual, I started with the broadest shapes and structure, using an HB pencil. When I add the tone most of the guidelines will disappear under shading, so a light touch is not necessary.

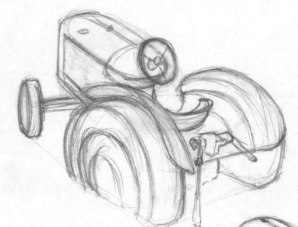

Step 2
Refining the shapes and adding detail, I made several sight measurements and adjusted proportions as necessary.

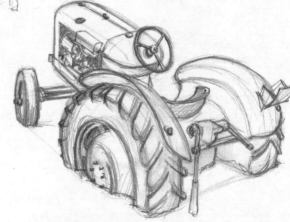

Step 3
Confident with my basic drawing, I drew finer detail in bold marks, already introducing some suggestions of tone along the way.

HANDY HINT

To avoid accidental smudging, lay a clean piece of paper between your hand and the drawing.

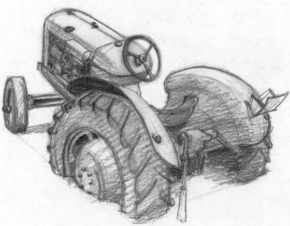

Step 4
For the first layer of shading I switched to a softer pencil (2B) and used the side of the lead to broadly cover all the main masses of tone. Then I shaded the darkest shadows more heavily.

Step 5

Drawings like this can easily turn into a muddy mess, so this stage is vital. I looked for any sharp tonal shifts and emphasized them with shading and erasing. Section by section, I refined the shading and erased errant marks, always keen to establish clear divisions between neighbouring tones.

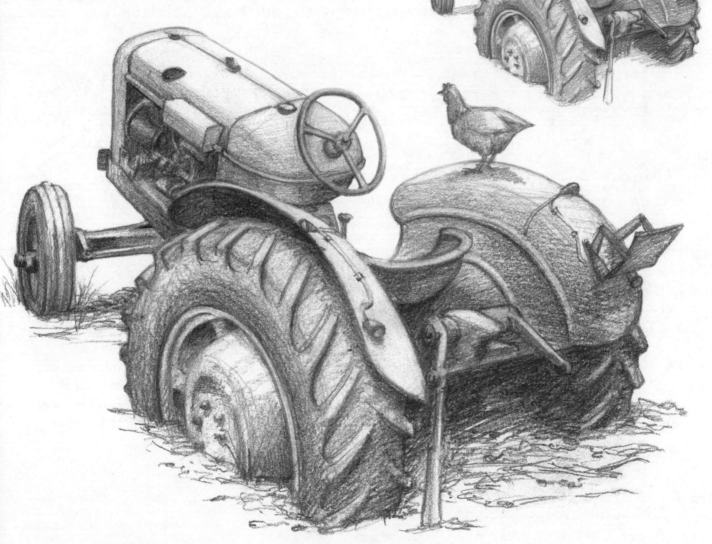

HANDY HINT

Squinting your eyes is a really effective way to judge tone on your subjects and spot inconsistencies in your drawings.

Step 6

To complete the rendering, I hardly looked at the subject. With a 4B pencil, I sharpened edges and balanced the tones across the whole, deepening shadows here and there so that nothing sat awkwardly. I also added some final details, including an obliging chicken that happened to pass by.

DRAWING WITH INK

Ink produces a dense black mark that can be applied as fine as a hair's breadth or in solid masses, depending on the tool employed. A bottle of black drawing ink is not expensive and will last for a long time. When dry, it cannot be erased or washed away, making it convenient when cleaning up pencil marks and for using along with other materials. White drawing ink, applied with a fine brush, is great for correcting mistakes and for adding highlights and accents. Make sure you shake or stir the bottle thoroughly before each use.

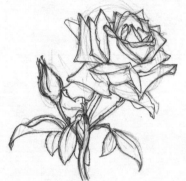 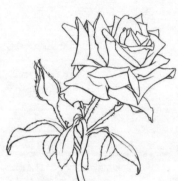 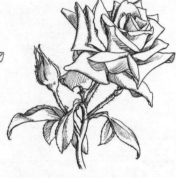

Step 1
The easiest way to ink drawings is to use fine-tipped drawing pens with integral ink reservoirs. Here, I have used a 0.3mm pen over fairly rough pencil guidelines.

Step 2
The pencil marks can be easily erased in broad strokes across the whole picture area, leaving a clean outline. However, the even line of a pen can look clinical and uninteresting.

Step 3
Going over some of the lines again with a broader pen (0.8mm) lends the line some variety. The difference is subtle, but the drawing looks more finished.

Step 4
Random shading direction is an easy introduction to shading with ink. With my 0.3mm pen, I started the shading with evenly spaced strokes over all the general areas of shade, roughly following the form of the plant.

Step 5
To complete the shading, I looked more closely at the subject and identified the variations of shade. Where the shading was darker, I altered the angle of the shading and stroked evenly spaced lines on top of the existing ones. A black pen cannot describe very pale tones, so they should be left white.

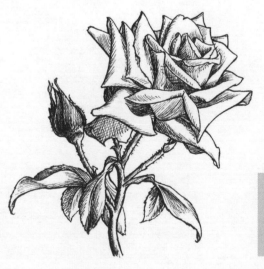

HANDY HINT

For more confident inking, turn the paper so that your hand can follow its natural arc for each stroke.

Using ink from a bottle requires a greater degree of confidence and steadiness of hand. Handling the free flow of ink is a kind of performance, for which each mark is rehearsed in the mind before being boldly committed to paper.

Steel-nibbed drawing pen
These old-fashioned pens have flexible nibs that make lines of varying breadth depending on the pressure you apply. They take a bit of practice to master and can be quite messy. Always wash the nib in clean water after use.

Bamboo pen
This is an excellent tool for thwarting any timid tendencies. Effectively, it is a shaped stick, dipped into ink. When fully loaded, the line is thick and blobby. As the ink runs low, this pen produces interesting scratchy marks for shading or suggesting texture.

Brush and ink
One good-quality round watercolour brush will do for most jobs, whether inking fine lines or filling in larger areas of solid black. A No. 3 or 4 brush is a versatile size, as long as it has a fine point. Immediately after use, wash the brush and reshape the point.

SOLID BLACK

Another quality of both black and white ink is their dense covering power over larger areas. Thus they lend themselves to more graphic approaches to drawing and design. Here is a bold graphic treatment of the rose motif drawn and filled in with a brush.

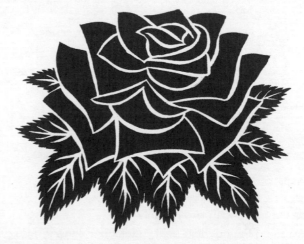

Step 1
Over rough pencil work, the first stage of inking was for the outlines only. For the serrated leaves, I laid down the point of the brush and dragged it away from the outside edges.

Step 2
Filling in with black was easy enough, but I was careful to leave myself some reminders of where the outlines would go.

Step 3
I then used white drawing ink to pick out the details, correct mistakes and complete the design. To allow for the white ink's thick consistency I painted these lines slowly and carefully.

PERSPECTIVE – A QUICK GUIDE

Newcomers to drawing often become over-anxious about perspective, but there is really no need. In fact, you will have already used perspective; in drawing the most rudimentary box you will have judged the angles by eye or by holding up your pencil. However, understanding perspective as a set of rules will bring greater clarity and order to what you do already.

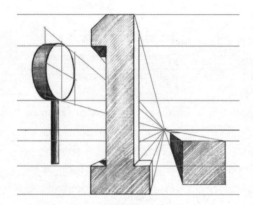

ONE-POINT PERSPECTIVE

The simplest form of perspective is for objects that are facing towards you on a level surface. All verticals remain strictly vertical and all horizontal lines on front-facing planes are drawn strictly horizontal, but those lines that recede from your view do so at angles that are easy to identify. This is known as one-point perspective.

The secret to getting perspective correct is in identifying the horizon, that is, the level of your eye in relation to the objects. Imagine you are sitting in front of these enormous blocks. Your eyes are level with the black horizon line. That means you can look down on the top of the rectangular block but look up at the ellipse opposite. Your position along the horizon determines the 'vanishing point', that is, the point at which receding angles meet. So here you are positioned between the number 1 and the rectangular block. From the vanishing point, a ruler will clearly indicate the receding angles.

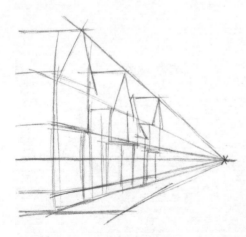

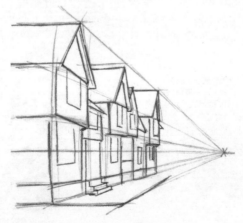

Step 1
These old buildings were roughly drawn using the out-held pencil method to judge angles. From there it was easy to extend the lines to find the vanishing point and use that to govern the rest of the angles.

Step 2
The perspective lines and the vertical lines form a grid to guide my drawing. I deliberately skewed some lines to show the buckling of the old buildings, and to show how divergences from the perspective grid are quite noticeable.

Step 3
With strong outlines in place, the guidelines can be erased and detail added, for a bold, unhesitant, finished picture. Note that the vertical beams on the receding plane appear narrower and closer together.

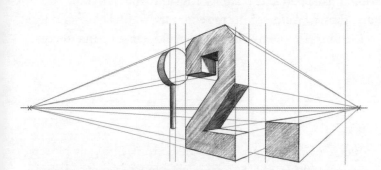

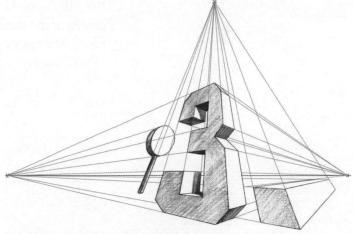

TWO-POINT PERSPECTIVE

As you may have guessed, one-point perspective does not address all potential perspective problems. More commonly seen and used is two-point perspective, which comes into play when objects are viewed from an angle.

Here the diagram is viewed from such an angle that none of the blocks is seen straight on. That means that both front and side faces recede from view and so therefore do the angles of their construction. Vertical lines are still drawn the same, but all horizontals, except the horizon, are angled upwards or downwards towards either of two vanishing points.

THREE-POINT PERSPECTIVE

This perspective scheme uses three vanishing points. Although it is easily observable, its effect on everyday scenes is subtle and it tends to be largely ignored by many artists – but it can be used to dramatic effect, especially in illustrations and comic books. The third vanishing point is located high above an object and governs the vertical recession of scale. Often that point is so high that its effect is minimal, but we can see it clearly in this exaggerated diagram. For a third vanishing point to be so low, one would have to be extremely close to the objects, close enough that the perspective scheme actually distorts the shapes of the objects to the left and right. In practice you would rarely include features as low as the horizon when drawing objects high overhead, since they would be outside your natural field of vision.

AERIAL PERSPECTIVE

When you look at a distant object, you see it through a greater mass of air than is the case with something nearby. The effect is a reduction of tonal contrasts over distance. In this illustration, for example, the details on the horizon are very pale, while those in the foreground are rich in tone.

Aerial perspective is always present, even over short distances. The rule of thumb is to apply less shade and weaker highlights to distant objects and increase the contrasts as objects get closer to the foreground.

PEN AND WASH

For this demonstration, I used pen and wash – a fine drawing pen to fix the details of the scene and diluted watercolour to render the light, shade and local tones. The rules of one-point perspective helped to make sense of the many receding angles.

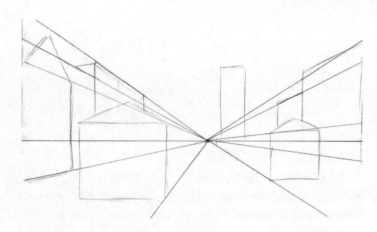

Step 1
After choosing the position of the horizon, I roughly placed the main blocks of the scene relative to my eye-line. Then I established the vanishing point and used a ruler to set down the main guidelines.

Step 2
Following my guidelines, I could draw the main blocks of the buildings and market stalls accurately.

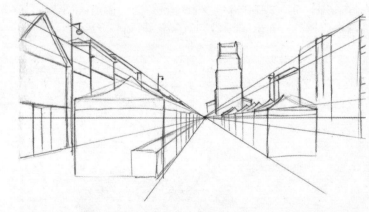

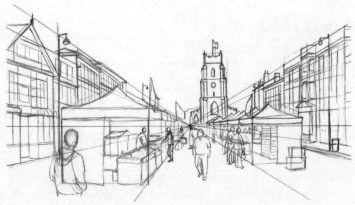

Step 3
More details brought the scene to life. People are easy to put in place using the horizon. From my viewpoint, standing on a step, my eye-line was slightly above the heads of the people on the ground, so their heads sit just below the line of the horizon.

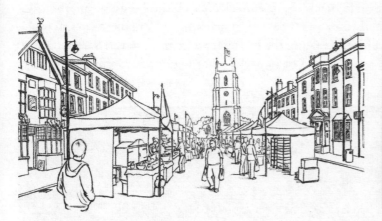

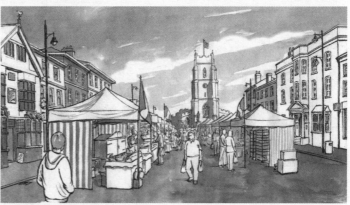

Step 4

It took a lot of time and patience to ink so many windows and details. I used a slightly broader pen to strengthen the lines of the foreground and thereby establish a sense of aerial perspective. Erasing all the guidelines left a clean and legible base for the rendering.

Step 5

I added well-diluted black watercolour paint with a medium (No. 6) round watercolour brush. It takes a bit of practice to use watercolour, so do some trials on scrap paper first. Keep the brush well loaded with paint, apply it in broad strokes and once it is applied do not fiddle with it.

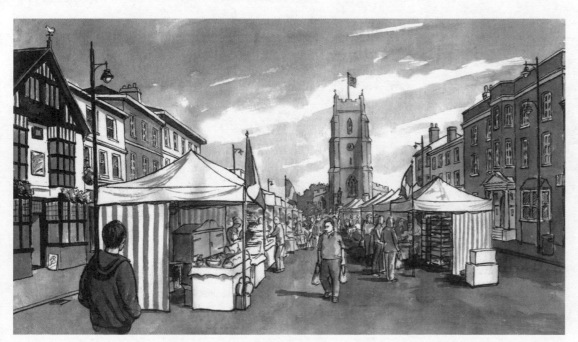

Step 6

I used two or three more washes of various strengths to establish different shadings and local tones and bring out odd details, always letting the previous wash dry first. I left bare white paper for the brightest areas of tone.

SCRAPERBOARD

For drawing white on to black, there is no cleaner method than scraperboard – a prepared surface of white gesso coated in dense black. You use a special tool to scrape into the black, revealing the brilliant white underlayer. Scraperboard comes in sheets of various sizes or in packs that include a scraping tool.

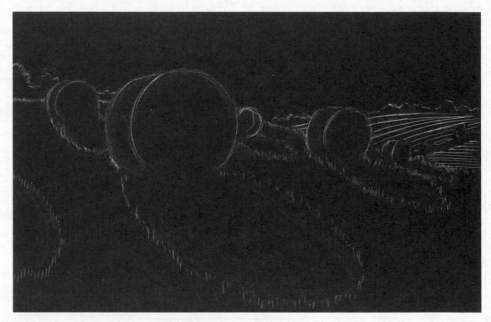

I often carry a pocket sketchbook to make visual notes of interesting subjects I come across. One summer evening this scene caught my eye. It is a good scraperboard subject because of the deep shadows and the texture of stubble in the harvested field. Together with my experience of drawing from the real landscape, this sketch would provide enough information for me to flesh it out into a more finished piece.

Step 1
After marking some light guidelines with white chalk, I inscribed the main outlines with the fine point of the scraping tool.

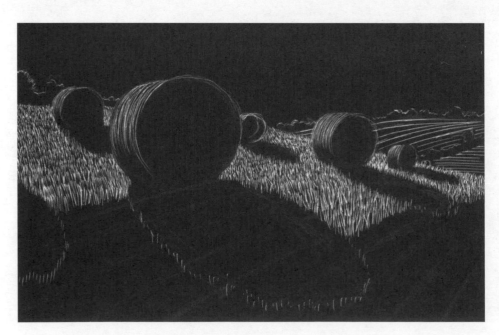

Step 2
Starting to scrape away the detail, I was careful to make the marks follow direction and describe texture. I worked on the stubble from the distance towards the foreground, strengthening the marks as I went.

Step 3

From the middle ground forwards, the stubble had to be set down in rows to convey the feel of a harvested field. Using the broader edge of the tool, I made the marks bolder as I worked down the picture. I started on the sky, intending to make it completely white, but at this point I liked the effect and decided to leave it with a suggestion of dramatic cloud.

HANDY HINT

Small errors can easily be rectified with black ink. When the ink is dry, it can be scraped back into, just like the original top layer.

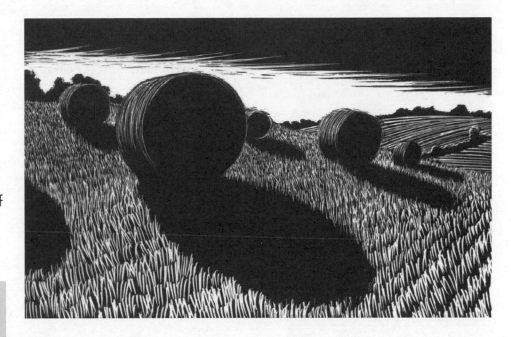

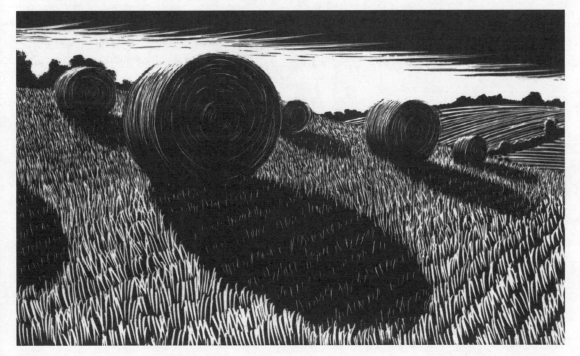

Step 4

I scratched some broken detail into the shadow areas to break up the masses of solid black. To finish, I brightened the highlights on the bales so that they bleach into the sky, an effect that is often seen in nature. Though no upper outline is present, the eye reads the complete shape.

CHARCOAL

Coming in various thicknesses, sticks of charcoal are cheap and versatile. Charcoal's soft, dark line encourages boldness, though it can easily be softened and corrected. Much of this medium's versatility comes from its smudginess, which may be harnessed for many different effects and techniques.

Charcoal builds up tone very quickly, making it a good choice for sketching fleeting subjects and atmosphere. Here I used charcoal, smudged, blended and erased, as a base for final brushpen line.

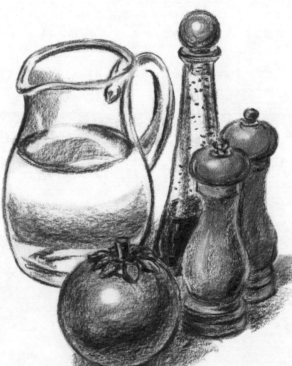

Used sparingly, charcoal is not unlike pencil in making lines of various weight according to the pressure applied. It can also be used for light shading when a short length is broken off and used on its side.

HANDY HINT

For detailed work, charcoal can be sharpened with a sharp knife. Rather than forming a point like a pencil, charcoal tends to work best when sharpened on one side only, rather like an old-fashioned quill pen. Always point the blade away from the body.

Exploring more of the medium's shading potential, for this example I smudged parts of the drawing with a fingertip to make even mid-tones, on to which I could then add more charcoal shading and lift off highlights with the point of an eraser.

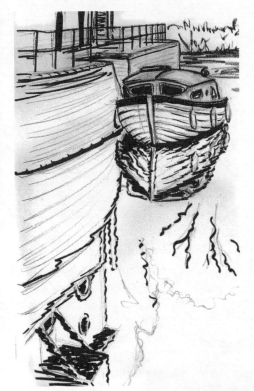

With this demonstration I want to show how quick and easy charcoal is to work with, especially if you do not attempt fine detail. This picture took less than an hour, helped partly by my use of brushpen to safeguard some of the detail against smudging, allowing me to work in broad sweeps.

Step 1

After roughing out the drawing in pencil, I pinned down the darkest details in brushpen. Note that I used wavering, broken marks to suggest movement in the water.

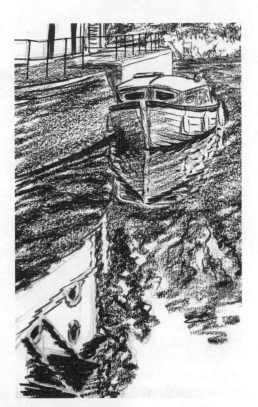

Step 2

With the side of a short length of charcoal (about 2.5cm/1in), I quickly covered the rough areas of tone.

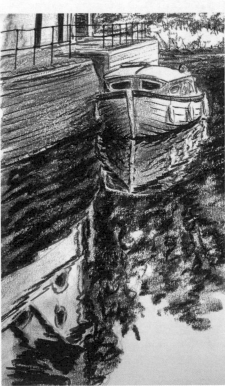

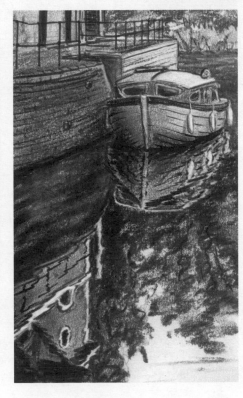

Step 3

I used my fingertip to smooth over the charcoal and work it into the grain of the paper. I then applied charcoal again in order to deepen the tones where necessary.

Step 4

To finish the picture I gave it a general tidy up, smoothing out some shading here, adding touches of detail there and also pulling out some highlights with an eraser.

PASTELS, CHALKS AND CONTÉ CRAYONS

PASTELS

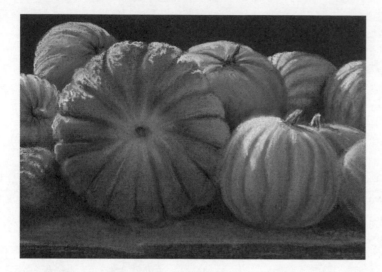

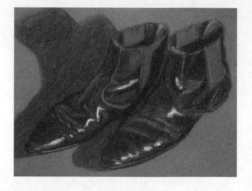

Most of this study was done in charcoal, but pastels were useful, not only for the bright highlights, but also to give a different feel to the elastic parts of the boots, distinguishing them from the shiny leather. As well as the usual short sticks, pastels also come in pencil form, which I found useful for the thin strips of highlight here.

With very opaque covering power, pastels can mark boldly on top of each other and are particularly suited to toned grounds. They can also be blended easily, either by drawing the different tones and colours into each other, or by smudging with a fingertip. In the drawing above, I used white and three shades of grey on very dark paper.

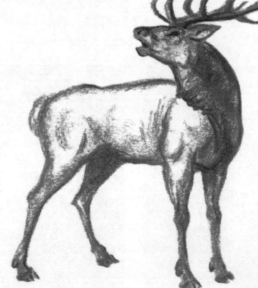

Pastels come in a vast range of colours and tones, so you can select them prior to drawing, reducing the need for pressure-sensitive use and later tonal adjustments. I used a mid-grey for most of this stag, against which I knew any charcoal detail would show clearly.

HANDY HINT

Finished drawings in charcoal, chalks or pastels should be protected against smudging with an artist's fixative spray, although hair spray is nearly as good and much cheaper. You can also fix a picture at various stages while working on it.

Pastels also lend themselves to vigorous, expressive mark-making. Note how the black pastel used in this drawing of a gull makes marks that are noticeably different to charcoal.

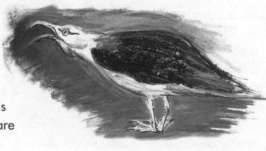

CHALKS

For simple highlighting and in plain white, blackboard chalk is just as good as pastel. With care, subtle effects can be achieved.

Children's blackboard chalks are much cheaper than pastels and have quite similar properties, but the range of tones and colours is extremely limited. In drawing this vigorous sketch I used various colours, but none was dark enough for the areas in shadow. Fortunately, chalk blends well with charcoal, which I used to complete the picture.

CONTÉ CRAYONS

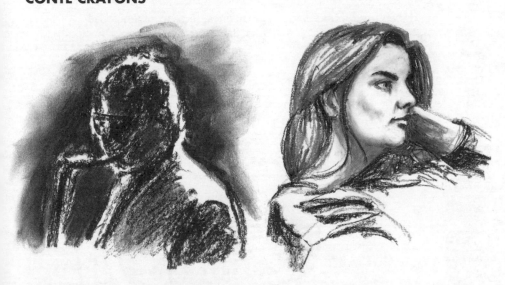

Here I used two shades of conté crayon. You can see that the two shades remain quite distinct from each other, though they could be blended if required.

Conté crayons are more stable than pastels and usually richer in tone and colour. The slightly waxy quality of mark can give a pleasing grainy look, especially on textured paper, or it can be smudged smooth and blended with the fingertip. Any highlights should be left as white paper because conté is hard to erase or to cleanly overlay with any white medium.

HANDY HINT

Sometimes a fingertip is too cumbersome for smudging and blending small details. Better control can be had using a 'tortillon' – a tightly rolled piece of paper formed into a pointed stick.

MARKER PENS

In many fields of commercial art, professional-quality marker pens have long been the tools of choice. In experienced hands they are unrivalled for speedy visualizing and can produce amazingly slick results. They come in a vast range of tones and colours, but they are very expensive. Fortunately, for black and white work, you can get away with just three or four shades of grey – and they work best on thin paper, which is inexpensive.

Even if your budget only stretches to a single pen, a wide range of tones is available to you. Just keep overlaying ink and the tones will build up. Here I used one mid-grey pen over rough pencil guidelines and finished in under ten minutes.

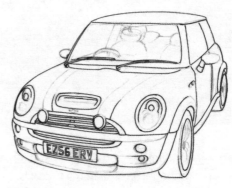

As is common practice in film design, I photocopied the pencil outline of this costume design several times and then used markers to rapidly try out different colour schemes. These renderings actually look better when swiftly undertaken.

Step 1

For a clean surface, I lightly traced my pencil sketch on to fresh paper. With a black drawing pen I marked the main outlines, leaving others to be delineated by tonal shifts or highlights.

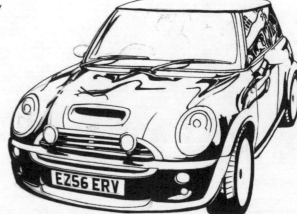

Step 2

With black ink I strengthened some of the lines and filled in the darkest areas around the bumper and tyres. I also very carefully observed the reflections in the paintwork and window, and inked their outlines.

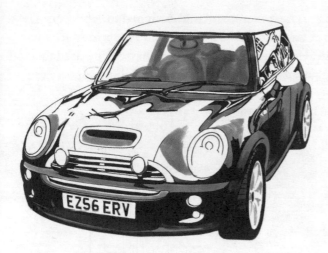

Step 3

For the rudimentary shading of the interior, I used two shades of pen in broad strokes. The markers I use have tips at either end: one broad and chisel-shaped, the other more finely pointed. I started shading the bodywork with the most obvious blocks of tone using the chisel end of a mid-grey pen. With the pen's fine point, I filled in smaller details.

Step 4

I went over most of the bodywork with a paler pen and put some detail into the headlights. With the car quite thoroughly inked, I could see where the tones needed deepening and built up the tones in layers. Marker pens blend together quite easily when you add the next tone before the first is completely dry. It may be wise to practise such effects on scrap paper.

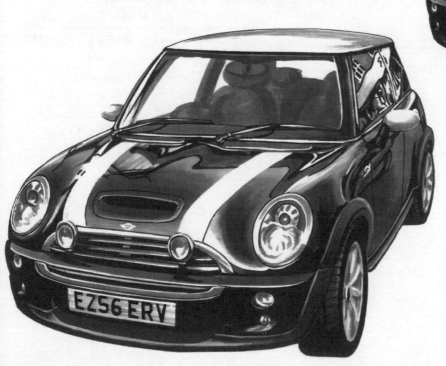

Step 5

Going over with a very pale pen, I was able to lighten the pigment on a few over-inked areas. I used a fine brush and white ink to correct some stray marks and add bright highlights and odd details. By watering it down, I could also use the white ink for more muted accents on the duller rubber and plastic surfaces.

HANDY HINT

Do not discard old markers when they start to run dry. They are very useful for many effects and when they dry out completely, they can be refilled as good as new.

FELT-TIPS AND WASH

Traditionally, felt-tip pens are cheap, colourful and designed for children. They are great for the vivid colour that children delight in, but for serious artwork they are generally too crude. However, with some care, they can be used to good effect, especially when we take advantage of their water-soluble properties.

In some cases, the graphic quality of cheap felt-tips can be satisfying if used quickly and sparingly.

I pressed my son into posing for this demonstration. After arranging the pose and lighting, I made this small sketch to make sure it all worked compositionally. Such preparatory work makes you familiar with the subject, settles the model and ultimately saves time.

Step 1
On heavyweight watercolour paper, I next established a more finished drawing, mainly concentrating on the face and hand. I was not worried about the arms and background at this stage.

For this painterly effect, I used a thick black felt-tip to roughly shade the deep shadows. Then I used a wet brush to blend the marks and carried some of the ink over to the paler parts to paint on more gentle shading.

Step 2

I outlined the eyes and some of the finer details in permanent ink with a black drawing pen. For the remaining outlines I used a mid-grey felt-tip, then erased the pencil guidelines.

Step 3

I used two shades of grey felt-tip to apply rough shading, following the curves of the surfaces with my strokes. It looks a bit coarse, but there is a strong sense of light.

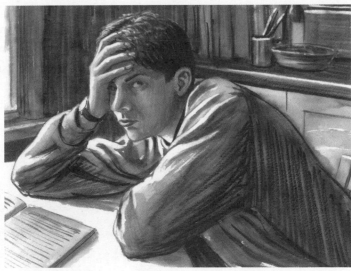

Step 4

With a broad brush, I painted water over the felt-tip marks to soften, blend and blur the surface. I worked quickly and stopped before the picture became too muddy. Notice the outlines remain unblurred where I used permanent ink to retain those parts of the drawing.

Step 5

Once the paper had dried I restated some details with the felt-tips. Then I lifted out some highlights: using water on a small brush I remoistened areas and dabbed them with a dry tissue to pull the ink off the paper. For the brightest highlights, I painted on some neat household bleach with a fine brush.

WATER-SOLUBLE MATERIALS

Strictly speaking, drawing and painting are quite different disciplines, but as we have seen, painterly effects can be applied to drawings, and drawing materials can be used in painterly ways. There are some materials especially made for these purposes – pencils and crayons that behave like any other but dissolve and blend with the application of water.

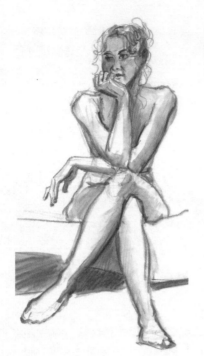

PENCIL

I use a soft, dark, water-soluble pencil for most of my quick sketches. The mark is the same as an ordinary pencil, but it gives me the option of very quickly adding some gentle wash tones if I so choose.

The same pencil can be used for full tonal renderings (right). Here I built up the tones in two or three layers, letting the water dry in between. To lift out highlights, I moistened the pencil marks and used an ink eraser.

CRAYONS

For larger sketches, water-soluble coloured crayons will quickly cover large expanses with rich colour and tone. They are fun to use, going on in broad strokes and blending effectively with a wet brush.

While this crayon treatment (right) was still wet, I added some deeper tone and detail with partially diluted ink.

COLOURED PENCILS

Water-soluble coloured pencils do not have the same smoothness as the graphite version, but they come in various shades and colours. For this costume study, I used three shades of brown on previously ink-tinted paper. For highlights, I used a white pencil and ink eraser.

DRAWING
STILL LIFE

INTRODUCTION

Still life is a very well-practised area of drawing and painting and has been the route by which many artists have learnt about techniques and style. It is the most easily available of art's themes and does not require a model or a fine day. The artist has only to look around his or her home to find all he or she needs for an enjoyable drawing session.

Perhaps because of its comparatively small scale or domestic nature, it has taken time for still life to be appreciated, and from about 1600 onwards until the 20th century it sat firmly at the bottom of the ladder in the hierarchy of artistic themes. Then still life, or *nature morte*, as the French call it, began to be recognized as having just as much significance in the art of drawing and painting as portraiture, history painting, figure painting, or landscape. The realization grew that a brilliant Chardin still life was as good if not better than any painting by a lesser artist, however elevated the theme.

In one sense it is an easy option: all of it can be produced in the studio and it has none of the problems associated with other types of art. Unlike people, the objects of a still life do not move and they do not need rests. As a subject for novice artists, still life is ideal because any objects can be used and you can take all the time you need in order to draw them correctly.

Drawing still life opens your eyes to the possibilities of quite ordinary items becoming part of a piece of art. Around any house there are simple everyday groups of objects that can be used to produce very interesting compositions. If you try out the suggestions given in the following pages you will quickly learn how to choose objects and put them together in ways that exploit their shape, contrasting tones and sizes, and also the materials that they are made of.

The study of the art of still life in this section of the book starts at a very basic level. The exercises set out are intended to ease into the subject someone who has never really drawn before, yet also provide useful refreshers for those of you who are already practised in drawing. Primarily we deal first with drawing objects, building up from simple shapes to complex, before moving on to tackle the drawing of still-life arrangements.

With these too we start very simply and gradually bring in more and more objects to create themes; you will have no shortage of themes to choose from. Conversely, you will also discover that arrangements involving just a few objects can be as, if not more, effective. Some of the most famous still-life artists have restricted their arrangements quite drastically and still become masters of the genre.

I do hope that you enjoy exploring this area of drawing, and that by the end of this section of the book you will be looking at the objects around you with a keen awareness of the possibilities they offer for self-expression.

Barrington Barber

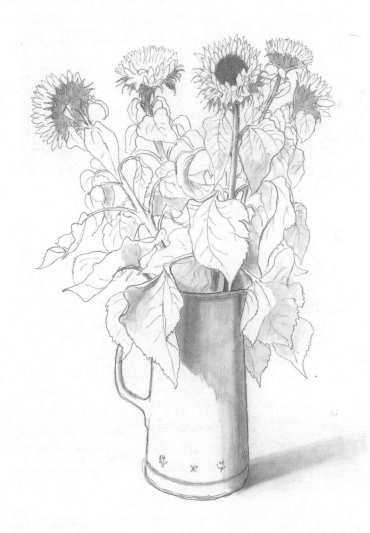

TECHNICAL PRACTICES

Every object you draw will have to appear to be three-dimensional if it is to convince the viewer. The next series of practice exercises has been designed to show you how this is done. We begin with cubes and spheres and continue with ellipses on the facing page.

We start with the simplest method of drawing a three-dimensional cube.

 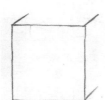 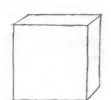

1. First, draw a simple square.

2. Draw lines that are parallel from each of the top corners and the bottom right-hand corner.

3. Join these lines to complete the cube.

This alternative method produces a cube shape that looks as though it is being viewed from one corner.

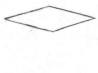

1. Draw a diamond shape, or parallelogram, elongated across the horizontal diagonal.

2. Now draw three vertical lines from the three angles shown; make sure they are parallel.

3. Join these vertical lines.

There is only one way of drawing a sphere. What makes each one individual is how you apply tone. In this example we are trying to capture the effect of light shining on the sphere from top left.

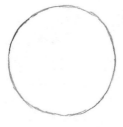 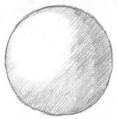 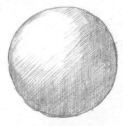 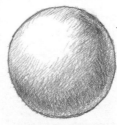 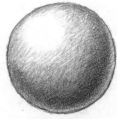 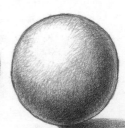

1. Draw a circle as accurately as possible.

2. Shade in a layer of tone around the lower and right-hand side in an almost crescent shape, leaving the rest of the surface untouched.

3. Subtly increase the depth of the tone in much of the area already covered without making it uniform all over.

4. Add a new crescent of darkish tone, slightly away from the lower and right-hand edges; ensure this is not too broad.

5. Increase the depth of tone in the darkest area.

6. Draw in a shadow to extend from the lower edge on the right side.

Ellipses practice: cylinders

Ellipses come into their own when we have to draw cylindrical objects. As with our previous examples of making shapes appear three-dimensional, the addition of tone completes the transformation.

1. Draw an ellipse.

2. Draw two vertical straight lines from the two outer edges of the horizontal axis.

3. Put in half an ellipse to represent the bottom edge of the cylinder – or draw a complete ellipse lightly then erase the half that would only be seen if the cylinder were transparent.

4. To give the effect of light shining from the left, shade very lightly down the right half of the cylinder.

5. Add more shading, this time to a smaller vertical strip that fades off towards the centre.

6. Add a shadow to the right, at ground level. Strengthen the line of the lower ellipse.

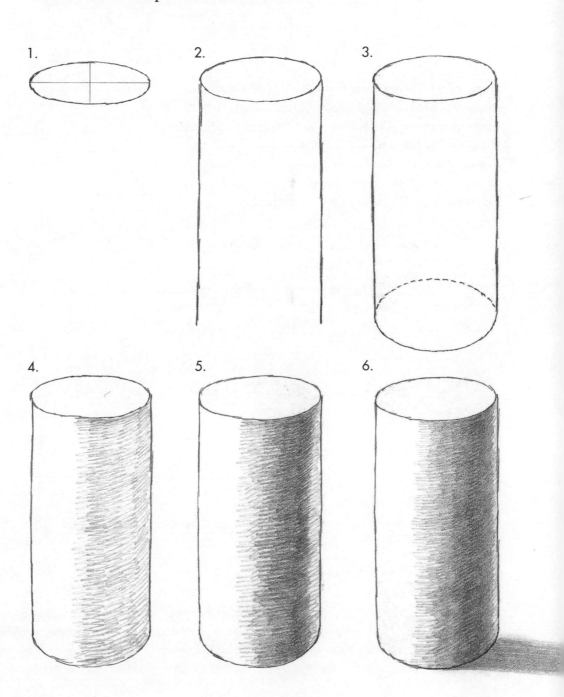

SIMPLE OBJECTS

When you are able to complete the practice exercises with confidence, it is time to tackle a few real objects. To begin, I have chosen a couple of simple examples: a tumbler and a bottle. Glass objects are particularly appropriate at this stage because their transparency allows you to get a clear idea of their shape.

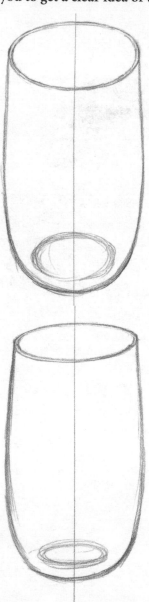

In pencil, carefully outline the shape. Draw the ellipses at the top and bottom as accurately as you can. Check them by drawing a ruled line down the centre vertically. Does the left side look like a mirror image of the right? If it does not, you need to try again or correct your first attempt. The example has curved sides and so it is very apparent when the curves do not match.

Now shift your position in relation to the glass so that you are looking at it from higher up. Draw the ellipses at top and bottom, then check them by drawing a line down the centre. You will notice this time that the ellipses are almost circular.

Shift your position once more so that your eye-level is lower. Seen from this angle, the ellipses will be shallower. Draw them and, as before, check your accuracy by drawing a line down the centre.

You have to use the same discipline when drawing other circular-based objects, such as bottles and bowls. Here we have two different types of bottle: a wine bottle and a beer bottle. With these, start considering the proportions in the height and width of the objects. An awareness of relative proportions within the shape of an object is very important.

After outlining their shapes, measure them carefully, as follows. First, draw a line down the centre of each bottle. Next mark the height of the body of the bottle and the neck, then the width of the body and the width of the neck. Note also the proportional difference between the width and the length of the bottles.

The more practice at measuring you allow yourself, the more adept you will become at drawing the proportions of objects accurately. In time you will be able to assess proportions by eye, without the need for measuring.

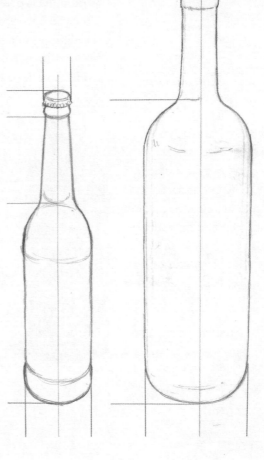

To provide you with a bit more practice, try drawing these objects, all of which are based on a circular shape although with slight variations and differing in depth.

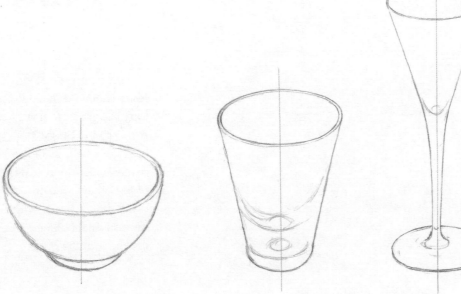
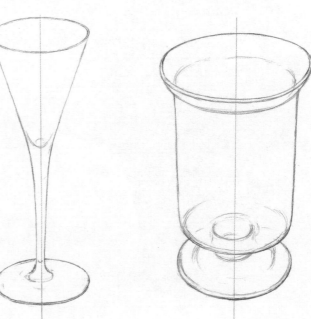

SURFACE TEXTURE

Solid objects present a different challenge and can seem impossibly daunting after you have got used to drawing transparent objects. When I encourage them to put pencil to paper, novice pupils often initially complain, 'But I can't see anything!' Not true. Solid objects have one important characteristic that could have been especially designed to help the artist out: surface texture.

The two darkly glazed objects presented here appear almost black, with bright highlights and reflections. Begin by putting in the outlines correctly, then try to put in the tones and reflections on the surface as carefully as you can. You will have to simplify at first to get the right look.

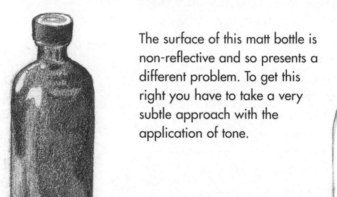

The surface of this matt bottle is non-reflective and so presents a different problem. To get this right you have to take a very subtle approach with the application of tone.

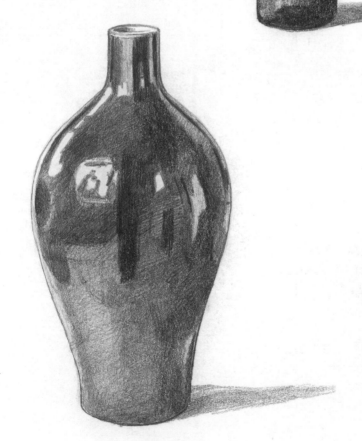

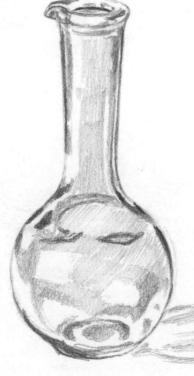

The problem with clear glass is how to make it look like glass. In this example the bright highlights help us in this respect. Other indicators of the object's materiality are the dark tones, which give an effect of the thickness of the glass.

Spherical objects

Spend time on these practices, concentrating on getting the shapes and the various textural characteristics right.

Take the lines of tone vertically round the shape of the apple, curving from top to bottom and radiating around the circumference. Gradually build up the tone in these areas. In all these examples, do not forget to draw the cast shadows.

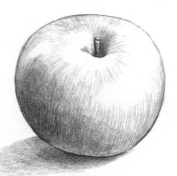

The surface of an egg, smooth but not shiny, presents a real test of expertise in even tonal shading.

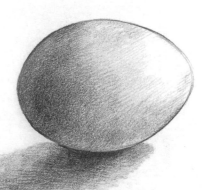

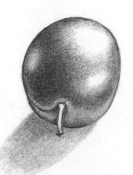

To capture the silky-smooth skin of a plum you need an even application of tone, and obvious highlights to denote the reflective quality of the surface.

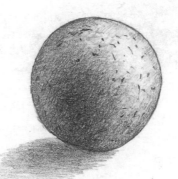

The shading required for this round stone was similar to that used for the egg but with more pronounced pitting.

The orange requires a stippled or dotted effect to imitate the crinkly nature of the peel.

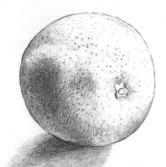

The texture of a lemon is similar to that of the orange. Its shape, though, is longer.

The texture of this hand-thrown pot is not uniform and so the strongly contrasting dark and bright tones are not immediately recognizable as reflections of the surrounding area. The reflections on the surface have a slightly wobbly look.

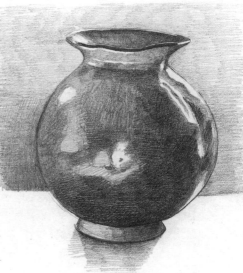

SHAPES AND PRACTICE

When you have learnt to draw simple shapes effectively, the next step is to try your hand at more complicated shapes. In this next selection, the first set of examples have an extra part or parts jutting out from a main body in the form of spouts, handles and knobs. Then we look at more subtle changes in shape across a range of objects.

These two items (right) provide some interesting contrasts in terms of shape. Note the delicate pattern around the lip of the sauce-boat which helps to define the plain white surface of the inside. The main point about the jug is the simple spout breaking the curve of the lip.

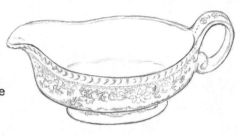

With our next pairing, of teapot and cafetière, the most obvious point of contrast is the texture. The cafetière is very straightforward, requiring only that you capture its cylindrical shape and show its transparency. The teapot is more interesting: a solid spherical shape with a dark shiny surface and reflections. When you practise drawing this type of object, ensure that the tones you put in reveal both its surface and underlying structure.

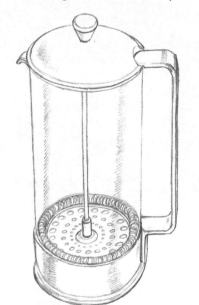

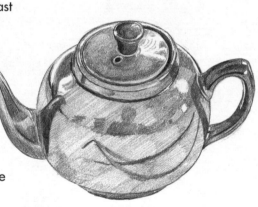

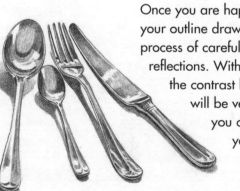

Once you are happy with the accuracy of your outline drawings, you can enjoy the process of carefully putting in the tonal reflections. With any shiny metallic object the contrast between darks and lights will be very marked, so ensure that you capture this effect with your use of tone.

Unusual shapes: wash and brush exercise

Next, to vary the technique of your drawing, switch to a brush and tonal wash, using either ink or watercolour. For this exercise I have chosen a shiny saucepan. As you will have already discovered when carrying out some of the

practices on the previous pages, obtaining a realistic impression of a light-reflecting material such as metal can only be achieved successfully if you pay careful attention to the tonal contrasts.

Step 1

Begin by outlining the shape of the saucepan. The critical proportion you have to get right is the relationship between the object's cylindrical body and its long, tubular handle. I chose to place the handle slightly angled towards me to get an effect of it jutting out of the saucepan.

Step 2

When the outline is in place, use a larger brush to put in the main areas of tone; in our example they are in a mid-tone of grey. The highlights were denoted by leaving the paper bare.

Step 3

For the final stage, take a smaller, pointed brush and work up the detail, applying darker and darker tones. If you inadvertently cover the bright areas, go over them with white gouache to re-establish the highlights.

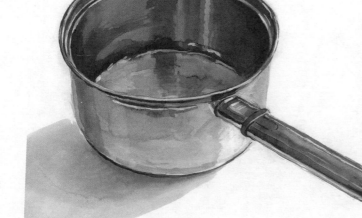

TEXTILES

The best way to understand the qualities of different textures is to look at a range of them. The key with each example is the way the folds of cloth drape and wrinkle. You will need to look carefully too at the way the light and shade fall and reflect across the folds of the material, because these will tell you about the more subtle qualities of the surface texture.

This scarf or pashmina made of the synthetic material viscose is folded over upon itself in a casual but fairly neat package. The material is soft and smooth to the touch, but not silky or shiny; the folds drape gently without any harsh edges such as you might find in starched cotton or linen. The tonal quality is fairly muted, with not much contrast between the very dark and very light areas; the greatest area of tone is a medium tone, in which there exists only slight variation.

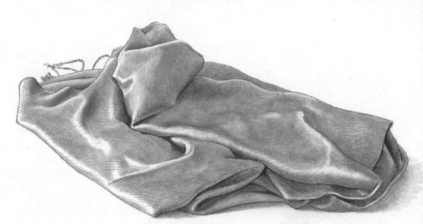

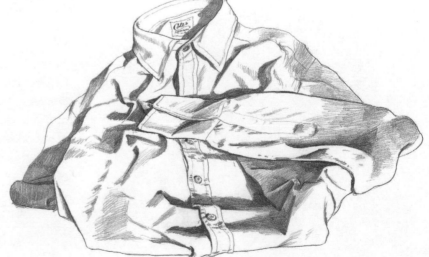

The folds in this large, woolly jumper are soft and large. There are no sharp creases to speak of. Where the previous example was smooth and light, the texture here is coarser and heavier. The showing of the neckline with its ribbed pattern helps to convince the eye of the kind of texture we are looking at.

This well-tailored cotton shirt is cut to create a certain shape. The construction of the fabric produces a series of overlapping folds. The collar and the buttoned fly-front give some structure to the otherwise softly folded material.

Here is a wool jacket, tailored like the shirt on the
previous page. Its placement on a hanger gives
us a clear view of the object's shape and the
behaviour of the material. The few gentle folds are
brought to our attention by the use of tone.

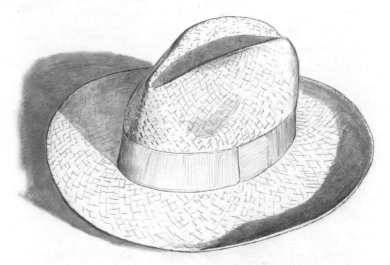

A straw hat produces a clear-cut form with definite shadows
that show the shape of the object clearly. The texture of the
straw, woven across the structure, is very distinctive. Well-
worn hats of this kind tend to disintegrate in a very
characteristic way, with broken bits of straw disrupting the
smooth line.

This satchel is drawn with quite dark
shadows in a few places but is mostly
fairly lightly toned to give the effect of
a light-reflecting surface, although the
material of the bag is black. If I had
felt it to be more true to the object, I
could have put a tone of grey over the
whole thing to indicate the colour.

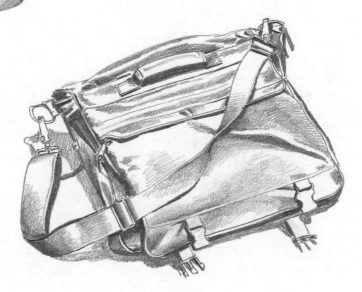

DIFFERENT SUBJECT MATTER

Over the next few pages we will look at some of the wide range of materials you can choose to draw in still-life compositions: paper, wood, glass, metal, bones, shells and stone. Each material, and indeed each object, has its own characteristics and surface texture and you will need plenty of practice to capture these distinct properties.

Paper

In the days when still-life painting was taught in art schools, the tutor would screw up a sheet of paper, throw it on to a table lit by a single source of light, and say, 'Draw that.' In fact, it is not as difficult as it looks. Part of the solution to the problem posed by this exercise is to think about what you are looking at. Although you have to try to follow all the creases and facets, it really does not matter if you do not draw the shape precisely or miss out one or two creases.

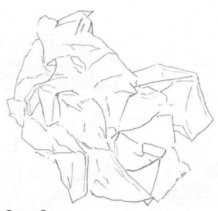

Step 1
Draw the lines or folds in the paper, paying attention to getting the sharp edges of the creases.

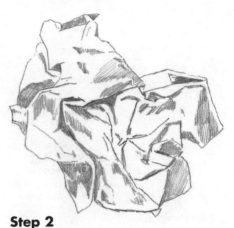

Step 2
Put in the main areas of tone.

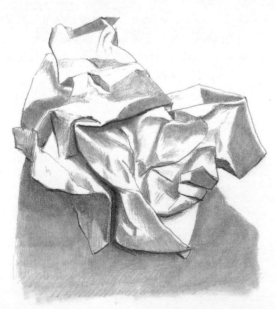

Step 3
Once you have covered each tonal area, put in any deeper shadows, capturing the contrasts between these areas.

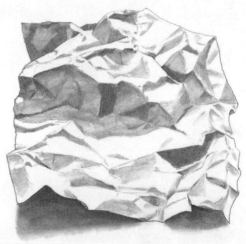

When you have completed the last step, try a variation on it. Crumple a piece of paper and then open it out again. Before you try to draw it, position the paper so that you have light coming from one side; this will define the facets and creases quite clearly and help you.

Follow the three steps of the previous exercise, putting in the darkest shadows last.

Wood

In its many forms, wood can make an attractive material to draw. Here the natural deterioration of a log is contrasted with the man-made construction of a wooden box.

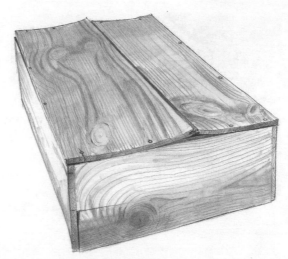

This box presents beautiful lines of growth which endow an otherwise uneventful surface with a very lively look. The knots in the thinly sliced pieces of board give a very clear indication of the material the box is made of.

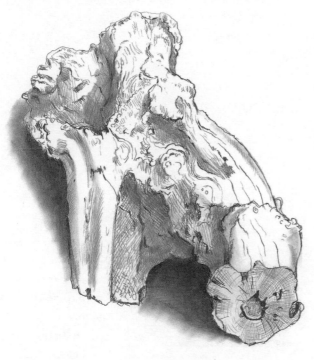

The action of water and termites over a long period has produced a very varied surface on the sawn-off log; in some places it is crumbling and in others it is hard, smooth and virtually intact apart from a few cracks.

The grain of the wood has been described in some areas to make this toy look more realistic. It is important not to overdo this effect and allow the surface colour to take precedence over the form.

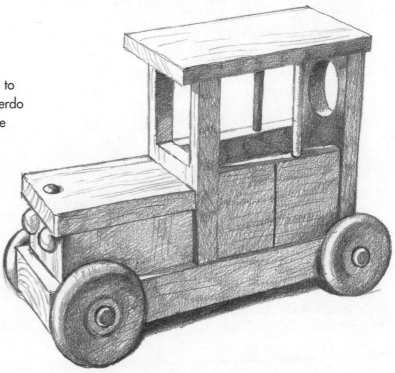

HANDY HINT

Look at the object you are drawing with your eyes half closed. You will see more clearly which parts are dark and which are light.

Glass

Glass is a great favourite with still-life artists because at first glance it looks almost impossible to draw. All the beginner needs to remember is to draw what it is that can be seen behind or through the object. The object is to differentiate between the parts where you can see through the object and the reflections that stop you seeing straight through it.

You will find that some areas are very dark and others very bright, often close together.

Make sure that you get the outside shape correct. When you come to put in the reflections, you can always simplify them somewhat. This approach is often more effective than over-elaborating.

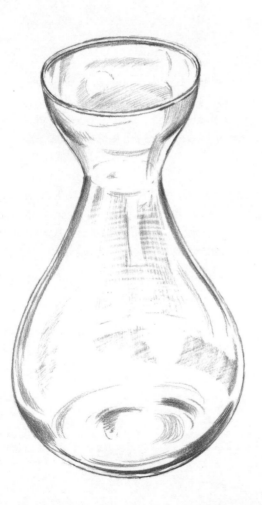

Draw the outline of this glass as carefully as you can. The delicacy of this kind of object demands increased precision in this respect.

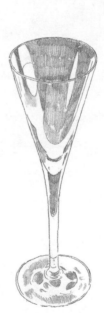

When you are satisfied you have the right shape, put in the main shapes of the tonal areas, in one tone only, leaving the lighter areas clear.

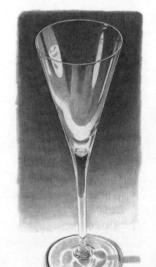

A glass vase, set in front of a white area of background. This allows you to see the shape of the glass very clearly. The tonal areas here will be minimal. If you are not sure whether to put in a very light tone, leave it out until you have completed the drawing, then assess whether putting in the tone would be beneficial.

Finally, put in the darkest tones quite strongly. Each of these three drawings should inform anyone seeing them very precisely about the object and its materiality.

Metal

Now we look at metal objects. Here we have a brass lamp and a silver candlestick, which give some idea of the problems of drawing shiny metallic surfaces. There is a lot of reflection in these particular objects because they are highly polished, so the contrast between dark and light tends to be at the maximum. With less polished metalware such as the watering can below, the contrast will not be so strong.

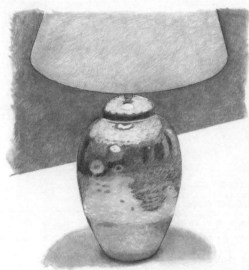

The beaten surface of this brass lamp gives the object many soft-edged facets. Because the light is coming from above, the darkest tones are immediately next to the strong, bright area at the top. The area beyond the darker tones is not as dark because it is reflecting light from the surface the lamp is resting on.

This battered old watering can made of galvanized metal has a hammered texture and many large dents. The large areas of dark and light tone are especially important in giving a sense of the rugged texture of this workaday object. No area should shine too brightly, otherwise the surface will appear too smooth.

A silver candlestick does not have a large area of surface to reflect from. Nevertheless the rich contrast of dark and light tones gives a very clear idea of how metal appears. Silver produces a softer gleam than harder metals. Note how within the darker tones there are many in-between tones and how these help to create the bright, gleaming surface of our example.

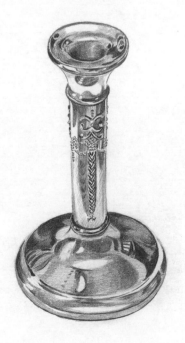

HANDY HINT

Take your time with metallic objects. It requires quite a bit of dedication to draw all the tonal shapes correctly, but the result is worth it. Your aim must be for viewers to have no doubt about the object's materiality when you have completed the drawing.

49

FOOD

Food is a subject that has been very popular with still-life artists through the centuries, and has often been used to point up the transience of youth, pleasure and life. Even if you are not inclined to use food as a metaphor, it does offer some very interesting types of materiality that you might like to include in some of your compositions.

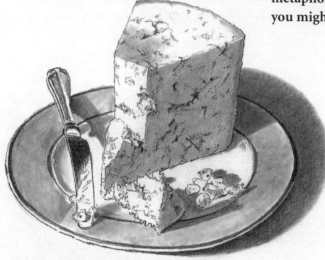

A piece of Stilton cheese, slightly crumbly but still soft enough to cut, is an amazing pattern of veined blue areas through the creamy mass. To draw this convincingly you need to show the edge clearly and not overdo the pattern of the bluish veins. The knife provides a contrast in texture to the cheese.

Here is a freshly baked stick of bread that looks good enough to eat. Where it is broken you can see the hollows formed by pockets of air in the dough. Other distinctive areas of tonal shading are evident on the crusty exterior. Make sure you do not make these too dark and stiff, otherwise the bread will look heavy and lose its appeal.

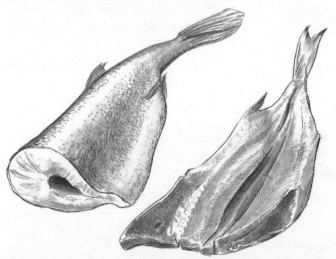

Two views of fish with contrasting textures: scaly outer skin with bright reflections, and glistening interior flesh. Both shapes are characteristic, but it is the textures that convey the feel of the subject to the viewer.

This large cut of meat shows firm, whitish fat and warm-looking lean meat in the centre. Although the contrast between these two areas is almost enough to give the full effect, it is worth putting in the small fissures and lines of sinew that sometimes pattern and divide pieces of meat.

PLANTS

Plants are very accommodating subject matter when you are learning to draw. A great many of them can be brought indoors to observe and draw at your convenience and they offer an enormous variety of shapes, structures and textures. To begin with, choose a flower that is either in your house, perhaps as part of an arrangement, or in the garden. In the exercise below we concentrate on the principal focal point, the head in bloom, although it is instructive to choose a plant with leaves because they give an idea of the whole.

Step 1
Using a well-sharpened pencil, which is essential when drawing plants, outline the main shape of the bloom and the stalk.

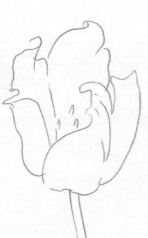

Step 2
Draw in the lines of the petals carefully.

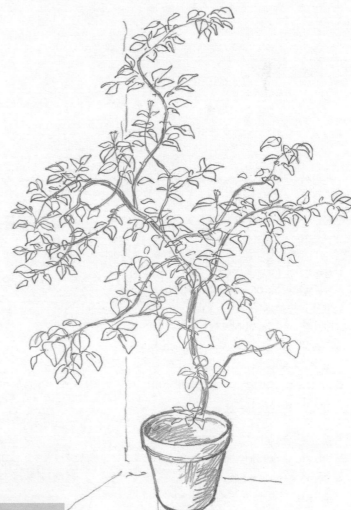

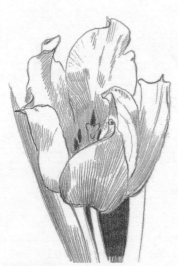

Step 3
Add any tone or lines of texture.

HANDY HINT

Once you start drawing larger plants, you realize that describing every leaf is very time-consuming. It is not necessary to count all the leaves and render them precisely – just put in enough to make your drawing look convincing.

Be very aware of the overall shape and construction of the branches and how the size of the leaves will vary. Look closely at this example and you will understand.

51

COMBINING OBJECTS

Once you reach this stage in your learning process, the actual drawing of individual objects becomes secondary to the business of arranging their multifarious shapes into interesting groups. Many approaches can be used, but if you are doing this for the first time it is advisable to start with the most simple and obvious.

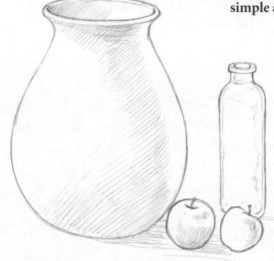

Contrast is the point of these combinations, so when considering the background go for a contrast in tone.

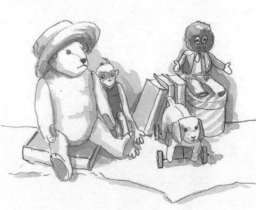

Unusual combinations
Here we look at less usual types of composition where we take something which is not normally considered to be an aesthetically pleasing object, but which, when drawn well and clearly defined, nevertheless produces an interesting result.

With clean laundry of towels, bathmats and tea towels piled neatly on the seat, this ordinary kitchen chair from the last century is as square and simple as is possible. The flat wall as background, and the fact that the whole scene is lit sharply with very little light and shade, produces a strong image.

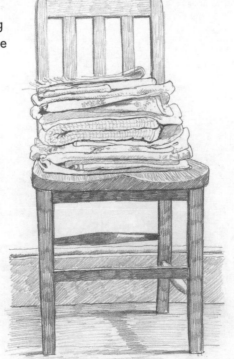

This group of stuffed dolls and teddies with a couple of books looks as though they might be on a nursery shelf.

Encompassed groups

Sometimes the area of the objects you are drawing can be enclosed by the outside edge of a larger object which the others are residing within. Two classic examples are shown here: a large bowl of fruit and a vase of flowers.

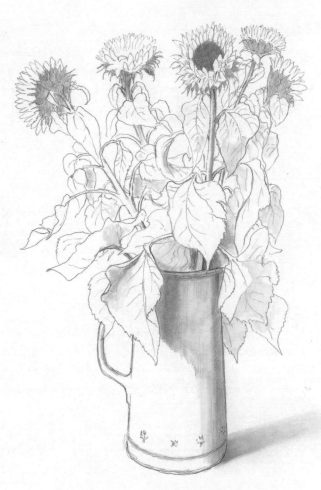

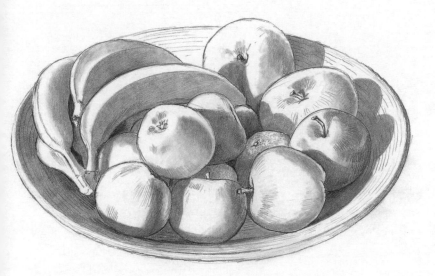

With this type of still life a variety of shapes is held within the main frame provided by the bowl.

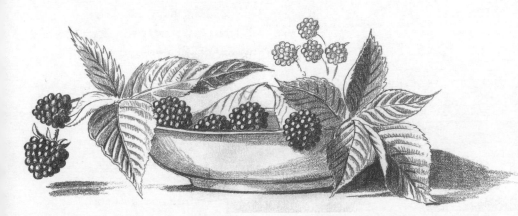

A large vase filled with flowers can be a very satisfying subject to draw. These sunflowers in a large jug make quite a lively picture: the rich heavy heads of the blooms contrast with the raggedy-edged leaves dangling down the stalks, and the simplicity of the jug provides a solid base.

The shiny, dark, knobbly globes of the blackberries and the strong structural veins of the pointed leaves make a nice contrast of shape and texture. The berries are just dark and bright tones, whereas the leaves have some mid-tones that accentuate the ribbed texture and jagged edges.

HANDY HINT

When you come to draw plants, especially flowers, your main task is to avoid making them look either hard or heavy. A very light touch is needed for the outline shapes and it is advisable not to overdo the tonal areas.

MEASURING AND FRAMING

Measuring up

One of your first concerns when you are combining objects for composition will be to note the width, height and depth of your arrangement, since these will define the format and therefore the character of the picture that you draw. The outlines shown below – all of which are after works by masters of still-life composition – provide typical examples of arrangements where different decisions about composition have been made.

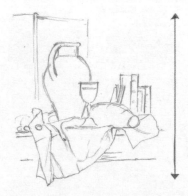

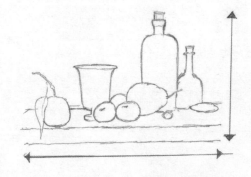

The height is the dominant factor in our first example (after Chardin). The lack of depth gives the design a pronounced vertical thrust.

In our second example (also after Chardin) the width is greater than the height and there is not much depth.

Depth is required to make this kind of arrangement work (after Osias Beert). Our eye is taken into the picture by the effect of the receding table top and the setting of one plate behind another.

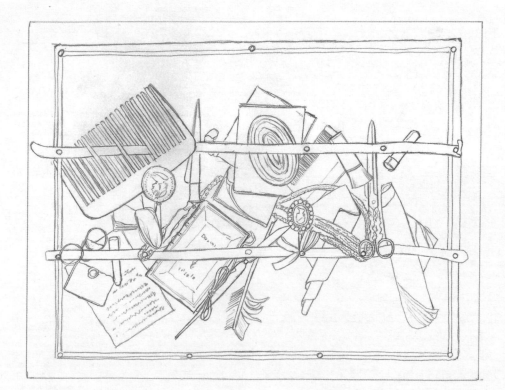

Now for something entirely different, this time after Samuel van Hoogstraten. This sort of still life was a great favourite in the 17th and 18th centuries, when it provided both a showcase for an artist's brilliance and a topic of conversation for the possessor's guests.

Almost all the depth in the picture has been sacrificed to achieve what is known as a *trompe l'oeil* effect, meaning 'deception of the eye'. The idea was to fix quite flat objects to a pinboard, draw them as precisely as possible and hope to fool people into believing them to be real.

Framing

Every arrangement includes an area that surrounds the group of objects you are drawing. How much is included of what lies beyond the principal elements is up to the individual artist and the effect that he or she is trying to achieve. Here, we consider three different 'framings', where varying amounts of space are allowed around the objects.

1. Here is a large area of space above the main area, with some to the side and also below the level of the table. This treatment seems to put distance between the viewer and the subject matter.

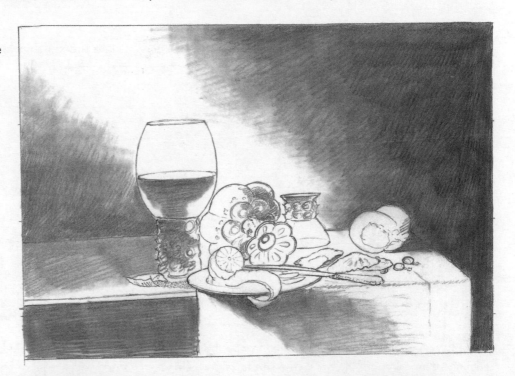

2. This composition is made to look crowded by cropping into the edges of the arrangement.

3. This is the framing actually chosen by the artist, Willem Claesz. The space allowed above and to the sides of the arrangement is just enough to give an uncluttered view.

LIGHTING

The quality and nature of the light with which you work will have a large bearing on your finished drawing. A drawing can easily be ruined if you start it in one light and finish it in another. There is no way round this unless you are adept enough to work very quickly or you set up a fixed light source.

Here we show the same three objects arranged in the same way in different lighting versions. Each one also shows the nature of the lighting, in this case an anglepoise lamp

with a strong light which shows the direction that the light is coming from.

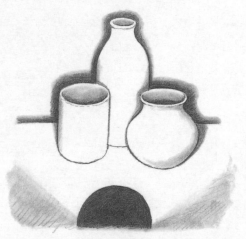

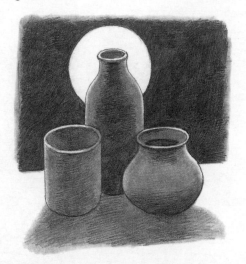

These three pots are lit entirely from the front – the light is coming from in front of the artist. The shadows are behind the pots and the impression is of flatter shapes.

Here the light is right behind the objects, so the pots look dark, with slivers of light around the edges. Except for the circle of the lamp, the background is dark.

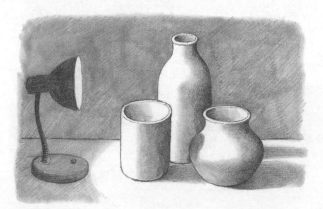

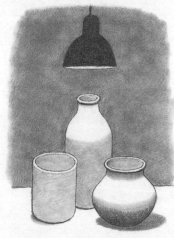

Lighting from one side gives the best impression of the three-dimensional quality of the pots. The cast shadows and the areas of shadow on the pots both help to define their roundness.

Lighting from above is similar to side lighting but the cast shadows are smaller and the shadow on the pots is, on the whole, less obvious.

The effects of light

Many an art student has been dismayed by the discovery that the natural light falling on a still-life arrangement has changed while a drawing is under way and that he or she has ended up with a mish-mash of effects. You need to be able to control the direction and intensity of the light source you are using until your drawing is finished. If this cannot be done with a natural light source, use an artificial lighting set-up as demonstrated on the opposite page.

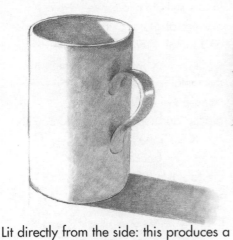

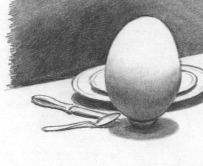

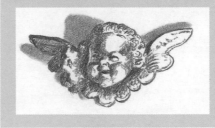

HANDY HINT

Directing light from below and to one side is traditionally the way to make objects look a bit odd, unearthly or sinister. Seen in an ordinary light this cherub's expression looks animated, but lit from below, as here, it appears to have a malign tinge.

Lit directly from the side: this produces a particular combination of tonal areas, including a clear-cut cast shadow.

Lit from above: the result is cooler and more dramatic than the first example.

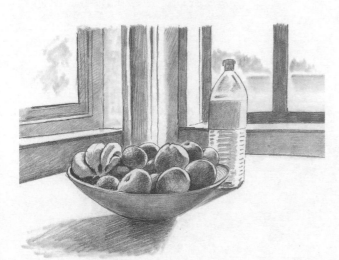

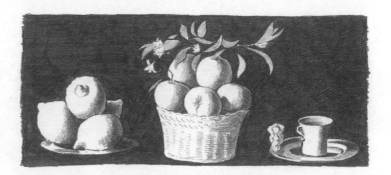

Now for a more traditional form of lighting. The bowl of fruit and the bottle of water are backlit from the large windows with the sun relatively low in the sky; I made this sketch in the evening, but you can get a very similar light in the early morning.

Lit strongly from the side, the strength of the light and the fact that this arrangement is set against such a dark background produces the effect of spotlighting, giving a rather theatrical effect.

MIXING MATERIALS

On these pages we look at the effects of mixing contrasting materials to create lively, varied still-life drawings. The first arrangement shown is one of the tests that has traditionally been set for student artists to help them develop their skill at portraying different kinds of materials in a single drawing. As well as trying this exercise, use your imagination to devise similar challenges for yourself.

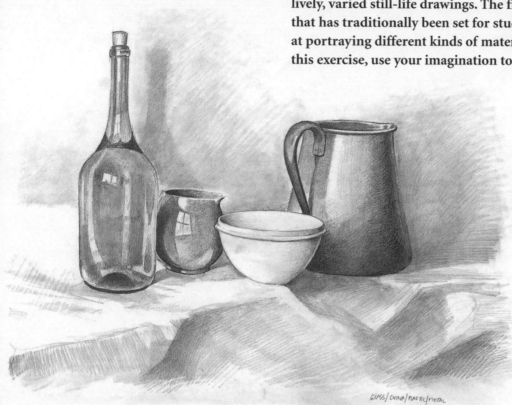

GLASS/CHINA/PLASTIC/METAL

In this still-life group we have a mixture of glass, china, plastic and metal. Note that the glass bottle is filled with water and that the metal jug has an enamelled handle. All the objects are placed on blocks hidden under a soft hessian cloth draped across the background and over the foreground.

HANDY HINT

Experiment with different media to describe a range of textures. For a radical approach you could also try incorporating collage with your drawing.

This is an interesting exercise, though it is a fairly difficult one. Here is an orange sliced in half and a partially peeled lemon, the knife resting on the plate beside them. The real difficulty of this grouping is to get the pulp of the fruit to look texturally different from the peel. The careful drawing of contrasting marks helps to give an effect of the juice-laden flesh of the orange and lemon.

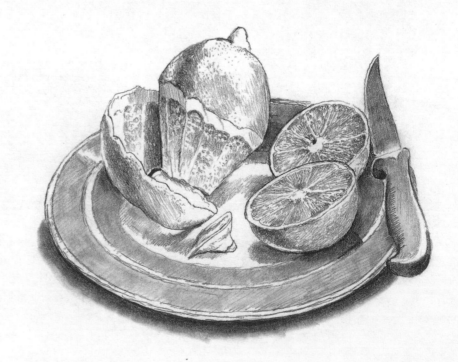

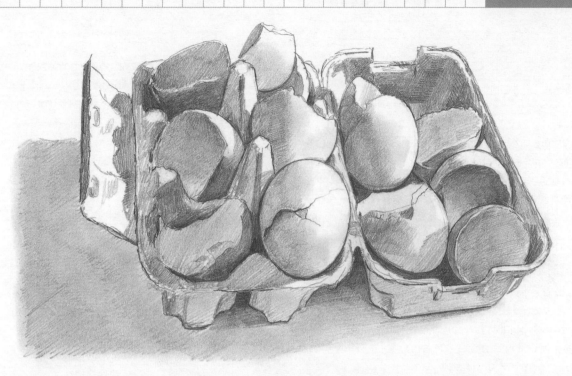

This exercise was quite fortuitous. I came across an egg-box full of broken eggshells after one of my wife's cooking sessions. She had replaced the broken shells in the box prior to throwing them away. The light on the fragile shells with their cracks and shadowed hollows made a nice contrast against the papier-mâché egg-box.

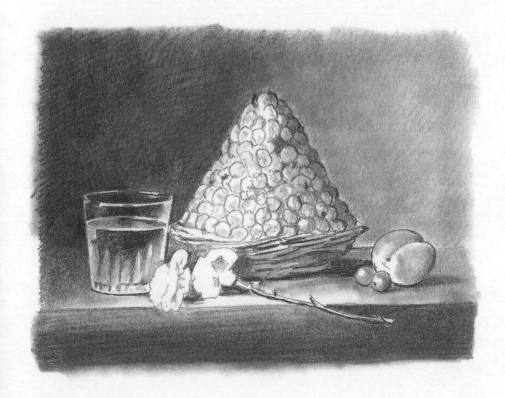

Next we look at a very simple picture by that master of French still life Jean-Baptiste-Siméon Chardin, who was so renowned in his own lifetime that many collectors bought his works rather than the more complex figure compositions by the artists of the Paris Salon. This picture shows fruit, water and a flower. The heap of strawberries on a basket is unusual as a centrepiece and the glass of water and the flower lend a sensitive purity to the picture.

PUTTING IT TOGETHER

On this spread is a step-by-step guide to developing a more monumental still-life composition. Take the time to set up a similar still life of your own, using all the skills that you have learnt, and follow the steps carefully.

Step 1

I decided on my arrangement and made a fairly quick sketch of it. The first thing I needed to establish was the relative positions and shapes of all the articles in the picture, so I made a very careful line drawing of the whole arrangement, with much correcting and erasing for accuracy. You could use a looser kind of drawing, but this is your key drawing which everything depends on, so take your time to get it right. Each time you correct your mistakes you are learning a valuable lesson about drawing.

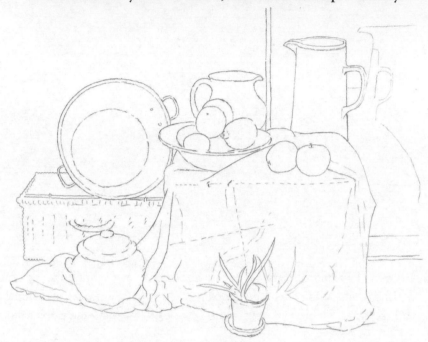

Step 2

After that I blocked in all the areas of the main shadow. Do not differentiate between very dark and lighter tones at this stage; just get everything that is in some sort of shadow covered with a simple, even tone. Once you have done this you will have to use a sheet of paper to rest your hand on to make sure you do not smudge this basic layer of tone. Take care to leave white all those areas that reflect the light.

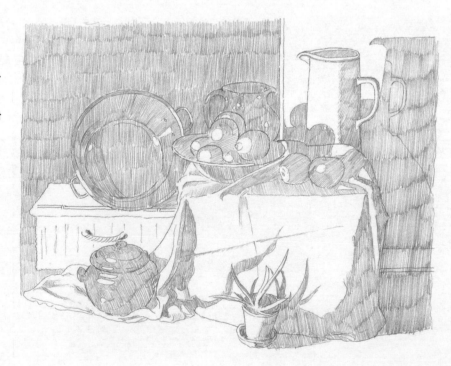

60

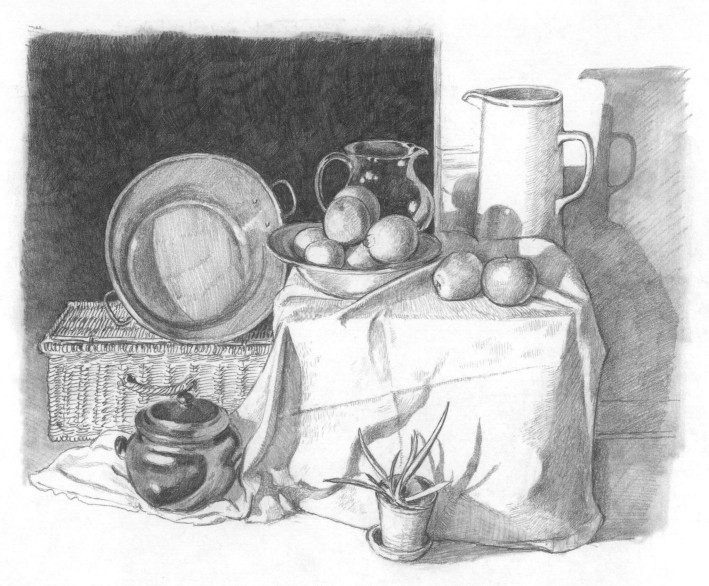

Step 3

Finally, I did the careful working up of all the areas of tone so that they began to show all the gradations of light and shade. I made sure that the dark, spacious background was the darkest area, with the large pan, the glass jug and the fruit looming up in front of it. The shadows cast by the plant and the drapes of the cloth were put in crisply, while the shadow of the jug on the wall required some subtle drawing.

Before I considered my drawing finished, I made sure that all the lights and darks in the picture balanced out naturally so that the three-dimensional aspects of the picture were clearly shown. This produced a satisfying, well-structured arrangement of shapes with the highlights bouncing brightly off the surfaces.

OTHER ARTISTS

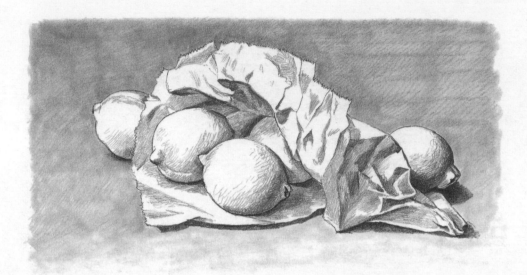

This picture of a few lemons spilling out of a crumpled paper bag has a simplicity and elegance that the British artist Eliot Hodgkin (1905–87) has caught well. It looks quite a random arrangement but may well have been carefully placed to get the right effect. It is a very satisfying, simple composition.

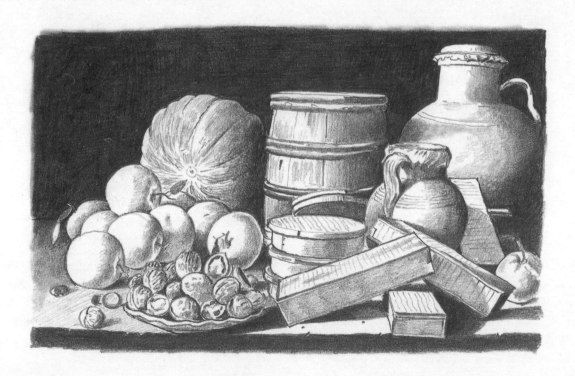

Conversely, this beautiful piece by the famous Spanish artist Luiz Meléndez (1716–80) is a full and crowded arrangement. The pots, packets and loose fruits and nuts both contrast and harmonize with each other, making for a solid and balanced-looking group.

DRAWING
LANDSCAPES

INTRODUCTION

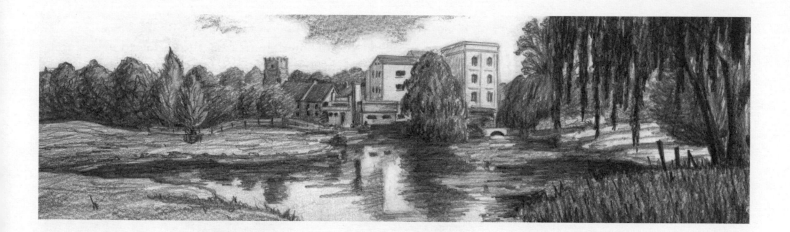

Whether you have access to coast or country, fields or forests, moors or mountains, you will never be short of subject matter; every landscape is worthy of your attention. With ever-changing skies and atmospheric conditions, even the most featureless wasteland provides rich pickings for the artistic eye.

Landscape differs from other areas of study in that the shapes and scenes are imprecise; if you draw a tree too large or small or position it in the wrong place, it will not detract from your artwork. This means that even the complete beginner should be able to draw with the boldness and confidence necessary for producing satisfying results.

This section of the book aims to instruct the reader in the drawing skills that may be applied to any type of landscape. It is designed as a course, with each new subject following on from the previous one. Step-by-step demonstrations will teach you to capture basic natural form and then gradually increase your facilities to render shade, texture and detail.

Though some of the exercises may be undertaken indoors, the great pleasure of landscape drawing comes when you venture beyond the comfort of the home. Whenever possible, get out among the elements and work directly from nature. The following pages will discuss some simple practical measures you need to take for the sake of your drawings and your physical comfort. Outdoors, the practice of sketching comes into its own, as a means of gathering information and for developing your skills. Sketches done

in the field can be developed into artwork at home, but portable materials are also perfectly sufficient for producing finished pieces on location.

We will investigate various materials and techniques and strive to develop your imaginative interpretation of natural scenes as well as your own expressive drawing style. It is down to you to decide what it is about a landscape that interests and inspires you, and with the lessons contained in this section, you will be able to capture something of your delight on paper.

Peter Gray

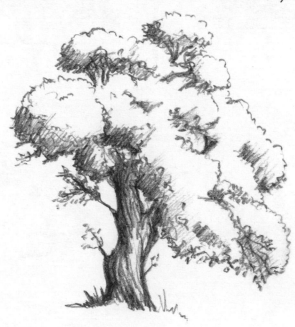

TREE FORMS

Proficiency in landscape drawing requires familiarity with the shapes, or 'forms', that recur in nature and how they are constructed. Mastering natural form is quite easy, but it takes careful observation to capture the subtle differences between similar landscape features. As one of the most common landscape motifs, trees offer interesting challenges and variations.

Some trees are quite uniform and symmetrical, following basically geometric shapes. Typically, however, they are more idiosyncratic, identifiable by species, but no two the same. As these silhouettes show, they are not solid objects, but composed of distinct parts that combine to form masses. The spaces in between these masses allow light to pass through.

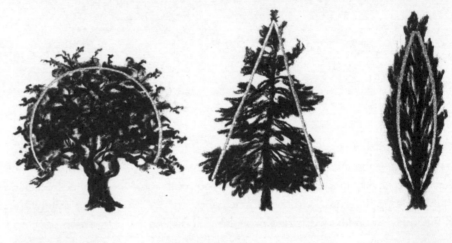

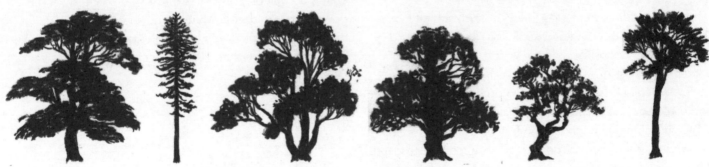

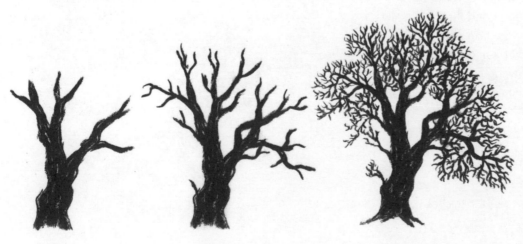

The best way to understand how trees are constructed is to start with the silhouette of a generic winter tree, with no leaves to hide the structure. The trunk is clearly the main solid chunk of a tree, from which grow a few heavy branches which sprout smaller branches. These in their turn produce more minor ones and so on to the network of tiny twigs from which the leaves grow.

Step 1
To draw the real thing, quickly sketch the trunk
and the general masses of foliage.

Step 2
Look more carefully at the
form and refine the detail
and silhouette. Note any
visible bits of branch.

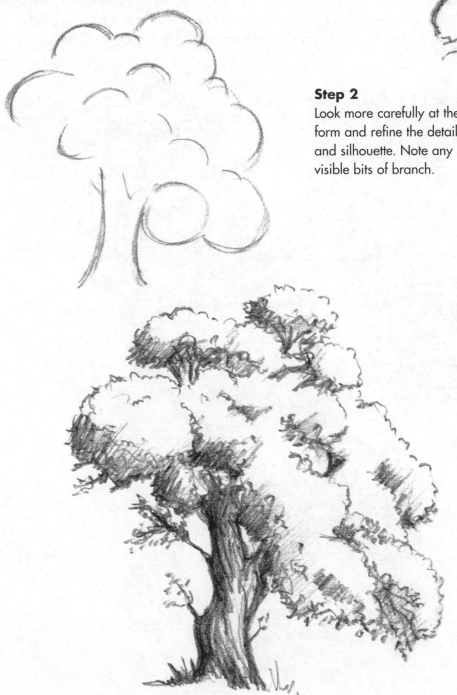

HANDY HINT

**Think of the tree as a series of spheres
supported by a number of cylinders.
Mentally simplifying the form makes the
job of drawing the foliage less daunting.**

Step 3
Using the side of the pencil, shade the
trunk and the underside of the masses
of foliage to describe the tree as a
three-dimensional form. It is often best
to leave plenty of bare white paper,
otherwise sketches can quickly become
muddy and confused.

SKETCHING PRACTICE

Before tackling expansive landscape scenes, it is well worth spending some time sharpening your sketching skills on smaller details. Make dozens of little sketches of many different objects, surfaces and plant forms, following the principles outlined on the previous pages. This will very quickly develop your facilities for observing organic forms and mark-making. It is also a gentle introduction to the rigours (and pleasures) of working out in the wild.

HANDY HINT

When sitting still outdoors you can get quite cold, so wrap up warm and maybe take a collapsible stool to keep you off the damp ground. If it is very sunny, a wide-brimmed hat will shield your face from the sun and save you from having to wear sunglasses.

I have worked in sketchbooks from A6 (10 x 14cm/4 x 5½in) up to A1 (60 x 84cm/24 x 33in) but I generally use the more practical A4 or A3 sizes.

HANDY HINT

Think of your sketchbook as a personal journal that nobody else ever need see, a space to make errors and false starts and to chart your artistic development.

A LANDSCAPE SKETCH

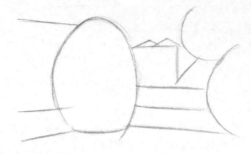

For a first foray into drawing a broader scene, find a location that is reasonably limited in layers of pictorial depth and conflicting textures. Make yourself comfortable enough to sit for an hour or so. Following the stages outlined here, you should find your drawing comes together quite quickly. Do not be too ambitious yet; keep the scale manageable (A4 or A3) and do not worry about any fiddly detail.

Step 1
Always start by establishing the broad masses with confident strokes. An HB pencil is probably best for this stage.

Step 2
Happy with my basic layout, I looked more carefully at the scene and refined the drawing to establish firm guidelines.

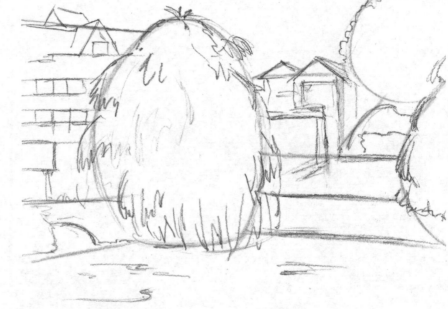

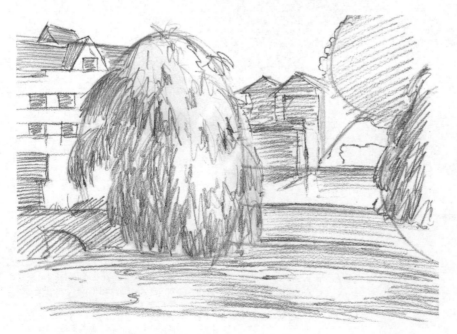

Step 3
Switching to a soft pencil (4B), I made an initial shading that was deliberately unfussy, roughing in all the main areas of shade with the same motion. The point here was to cover a lot of the white paper quickly, which moves the drawing along rapidly.

Step 4

Next I made a closer analysis of the tones, applying heavier shading where it was needed and stating some of the details along the way. I adjusted the direction of the pencil strokes to suit the surfaces I was trying to describe.

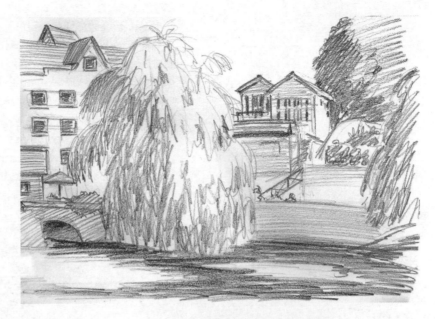

Step 5

Working over the whole drawing, I honed the details, squinting my eyes to discern the tones. A few minimal bits of erasing were all that was needed to clean up and finish off, as most of the underdrawing was lost amid the shading.

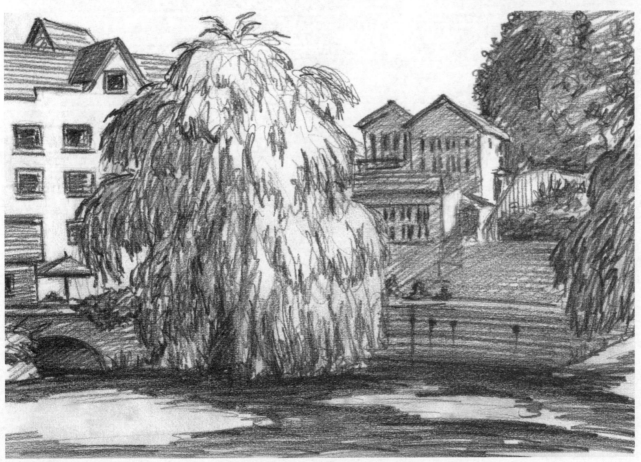

SKETCHING AIDS

CHECKING DIMENSIONS

When sketching from a landscape, the proportions of features at different distances from your viewpoint can be confusing and difficult to judge by eye. Use sight-sizing to help you to quickly check the dimensions within a scene. Holding your arm locked straight out in front of you, measure the length of an object as it appears along your pencil and mark the length with your thumb. That measurement can then be used to check against other dimensions. In this diagram, you can see that the distant stones register the same dimension in height as the foreground stones do in breadth.

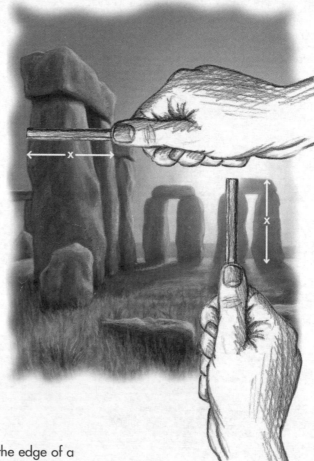

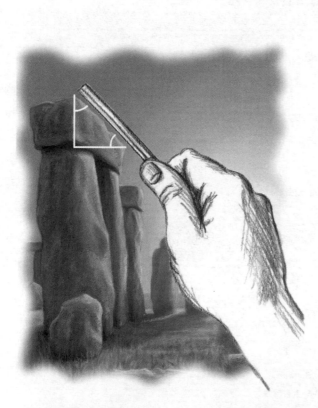

CHECKING ANGLES

Drawing landscape scenes often involves sloping lines, such as the edge of a mountain, the slope of a rooftop or the recession of a road or river into the distance. Accurately assessing the angles of such lines is important in drawing the scene convincingly. Again, the pencil can be used as an aid. Hold your pencil vertically about 30cm (12in) in front of your eyes then tilt it left or right until it lines up with the angle you wish to draw. Holding that angle, move the pencil down to the relevant area of your drawing.

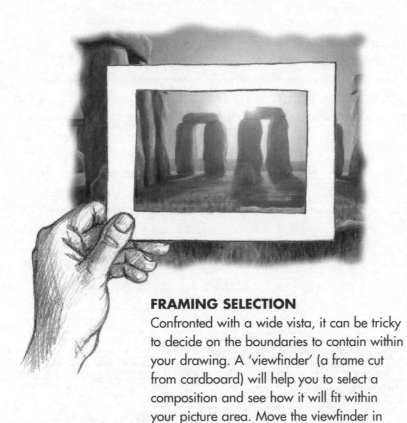

FRAMING SELECTION

Confronted with a wide vista, it can be tricky to decide on the boundaries to contain within your drawing. A 'viewfinder' (a frame cut from cardboard) will help you to select a composition and see how it will fit within your picture area. Move the viewfinder in and out to take in more or less of the scene. See how it looks upright (portrait format) or lengthways (landscape format).

When you have decided on a composition, try to fill the page as fully as possible, giving yourself plenty of space for bold lines and expressive mark-making. Working on a small scale restricts your movements and tends to produce overly fussy pictures.

71

PERSPECTIVE SKETCHES

A very basic grasp of perspective should be enough to bring order to the landscape and, through the process of drawing varied scenes, the principles should soon become instinctive. Sketching these two very different scenes involved little more than a casual reflection on the perspective at work. In each case, I was more occupied with textures, lighting and energetic mark-making.

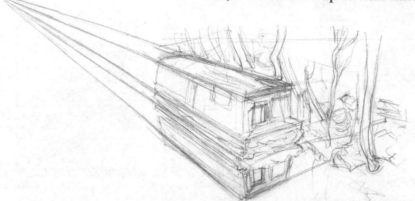

Step 1

Here I added receding lines to show the perspective involved. In practice, I would judge these angles by eye with the pencil (see page 70). Note how the perspective of the barge's shadow runs to the same vanishing point, as if an identical barge were glued to the underside.

Step 2

In firming up the outlines, my lines were scratchy and carefree. I kept the marks for the barge, trees, reflections and debris distinct from each other. Being parallel to the barge, the railings ran to the same vanishing point.

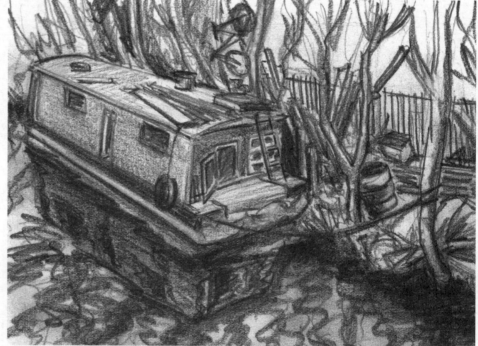

Step 3

With a heavy graphite stick, I enjoyed pushing tone around, smudging and virtually attacking the paper. When working with heavy tone it is important to keep the picture legible, even if you have to invent outlines, highlights or areas of deep tone for details to stand out against.

Step 1

Once I had established the horizon, I marked the rough outline of a lane and wall, all converging at the same approximate vanishing point. Then I roughed in the main masses and started to work on the outlines.

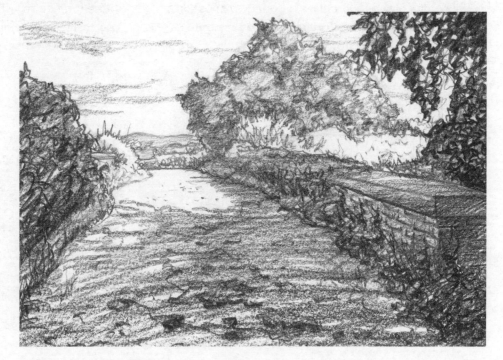

Step 2

Working up the detail, I paid particular attention to the end of the lane, to show it curving around a distant corner.

Step 3

I scribbled in the rough areas of shade in no time, conscious of the patches of bright sunshine in the middle distance.

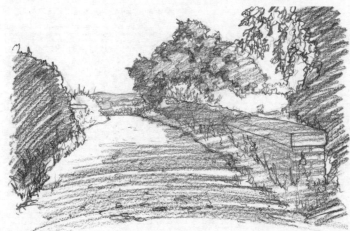

Step 4

In refining the tones, I used a range of marks to suggest the different textures. Not forgetting aerial perspective, I started with faint marks from the most distant features and worked towards the foreground, reserving the darkest tones for the nearest objects. For clarity, I left the patches of sunlight white. Landscape drawing very often involves managing a balance between lighting and local tone.

COMPOSITION AND SELECTION

The arrangement of elements within the picture area is one of the most crucial considerations for successful landscape art. Look at a lot of landscape paintings and photographs in books or galleries and try to work out why some have more impact or grace than others – it usually comes down to composition. The following croppings demonstrate some of the elementary compositional 'rules'. When you settle down to draw, consider different compositional possibilities before you commit a scene to paper.

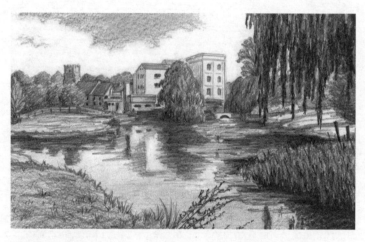

This is dull. Setting the horizon and main feature in the middle of the picture guarantees a boring composition. Broad masses of dark tone are clumped on one side, upsetting the tonal balance.

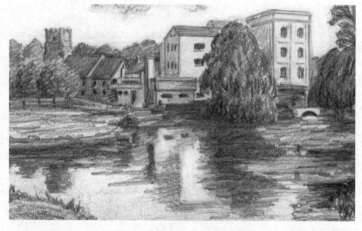

This selection zooms closer in on the buildings yet allows space for their reflections to play an active part in the composition. The higher horizon makes for a more decisive and effective use of space.

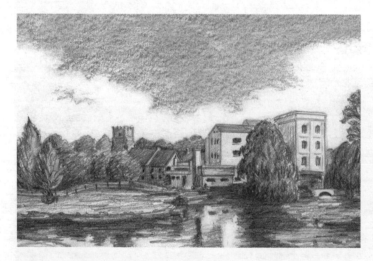

With a lower horizon, the water is largely cropped off and the sky is allowed enough space to feature strongly.

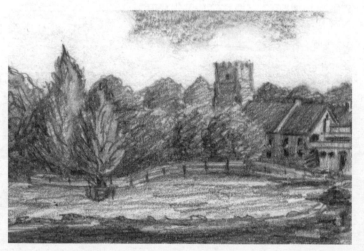

There is nothing to say you have to draw the dominant feature of a scene. You are free to select whatever interests you.

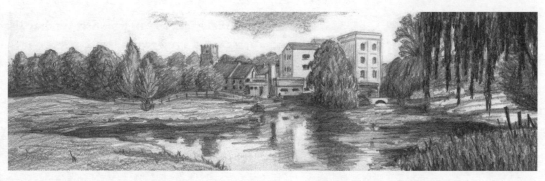

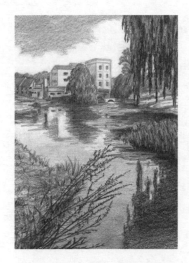

An extreme horizontal format is similarly effective, lending the scene a cinematic quality.

This more extreme vertical framing (below) reduces the scene to three layers of depth. Excluding peripheral detail can give a picture intrigue and impact.

This portrait format enhances the meander of the river to reveal a pleasing 'S' shape curve. The cropping is carefully considered for tonal balance.

HANDY HINT

To compose different-shaped pictures, two L-shaped cut-outs and some paperclips will make a viewfinder of any proportions.

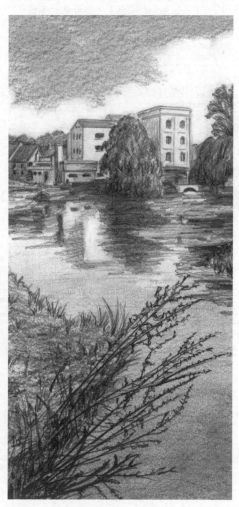

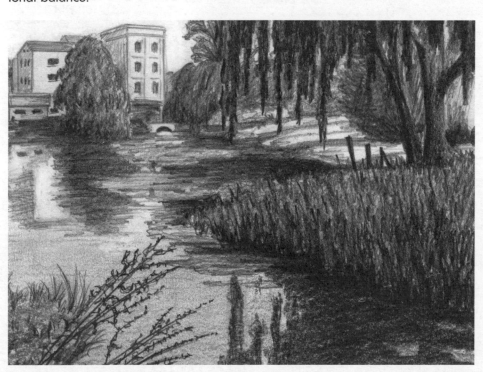

Here the sweep of the river leads the eye into the scene in a graceful curve. The darker tones bring a different feel to the picture.

A LANDSCAPE IN PEN AND WASH

Different materials, as you will discover, have various strengths and weaknesses, and some lend themselves better to certain subjects than others. They may also be used in conjunction with each other to make best use of their respective qualities. A classic combination is pen and wash, in which the pen pins down firm outlines and the watercolour wash quickly covers broad areas of tone. Make sure you use waterproof ink and heavyweight paper.

Step 1
I made sure the basic shapes of my pencil guidelines were fairly accurate before working with the permanent ink of the pen.

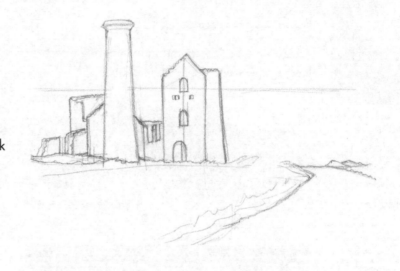

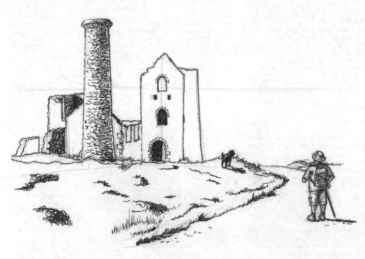

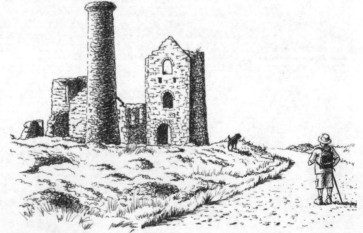

Step 2
With a fine felt-tipped drawing pen (0.5mm), I carefully retraced the outlines and started to add shade in textural marks. During this stage a rambler came by, so I quickly drew him and his dog to give the scene some depth and scale.

Step 3
Having finished all the texture and shade, I could erase my pencil guidelines. The drawing was nearly complete and it only remained to use the watercolour to add broad washes of tone.

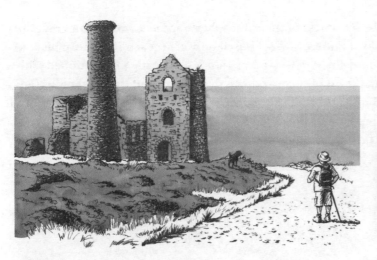

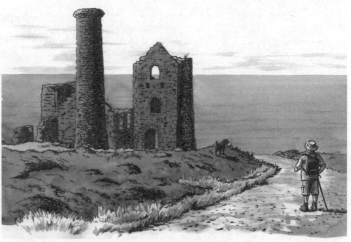

Step 4

I mixed up plenty of very thin black watercolour in an old saucer and used a broad brush to wash over the sea and buildings in one go. It is important to do this quickly to avoid streaks. I covered the scrub in the foreground with a darker tone and then set the drawing aside to dry.

Step 5

Some more touches of watercolour quickly strengthened the tones and added some detail here and there. Some subtle strokes give texture to the sea and suggest the distant clouds.

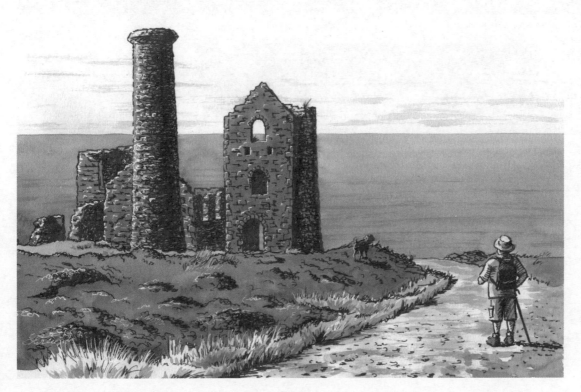

Step 6

At this stage the sun was about to move behind the front face of the stonework, so I worked very speedily to capture the glancing highlights before they disappeared. I used white ink with an old-fashioned dip pen, which was also useful for lifting out some grass and highlights in the foreground.

A LANDSCAPE IN CHALK AND CHARCOAL

To complement the bleakness of this atmospheric scene, I worked on grey paper. Other than the pencil underdrawing, I used only charcoal and a cheap piece of children's blackboard chalk. The composition is classically proportioned with the horizon about a third of the way down the picture and the focal point (an old lighthouse) about a third of the way in from the side. Controlling the aerial perspective was important to the atmosphere, so I worked generally from the far distance towards the foreground, strengthening tones along the way.

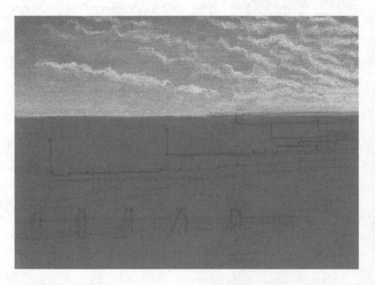

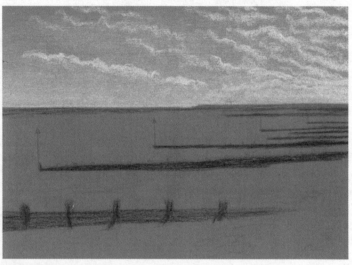

Step 1
I kept the rough pencil drawing very simple. Using the side of a short length of white chalk, I laid on the basic tone of the sky. I smudged and blended the sky tone with my fingertip to produce a fairly smooth gradient, then drew the clouds on top with more white chalk. These radiate from a vanishing point to the right of the picture.

Step 2
I applied the first strokes of charcoal, taking care not to press too hard. Subtlety is everything with an atmospheric picture and it's easier to strengthen tones later than it is to weaken them.

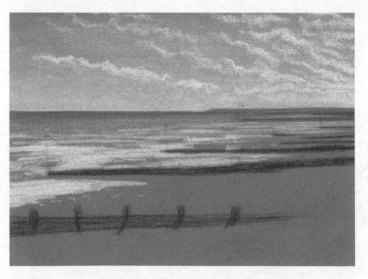

Step 3
I added the white of the water around the groynes where it reflected the light of the sky. I also smudged the charcoal of the sea for a smooth transition towards the horizon.

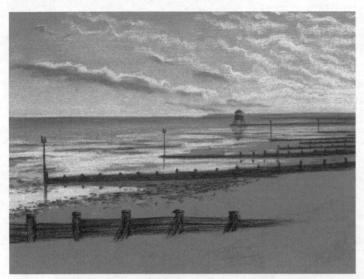

Step 4

With the highlights of the water in place I could properly establish the charcoal drawing and control the tones. Smudges of charcoal in the bigger clouds gives them solidity. Happy with the general background, I added the detail of the posts and lighthouse as well as their reflections.

Step 5

Here I strengthened the tones of the seaweed in the foreground to bring it forward in the picture and added a few bright highlights. Aerial perspective is not simply about the darkness or lightness of things, but their relative contrast.

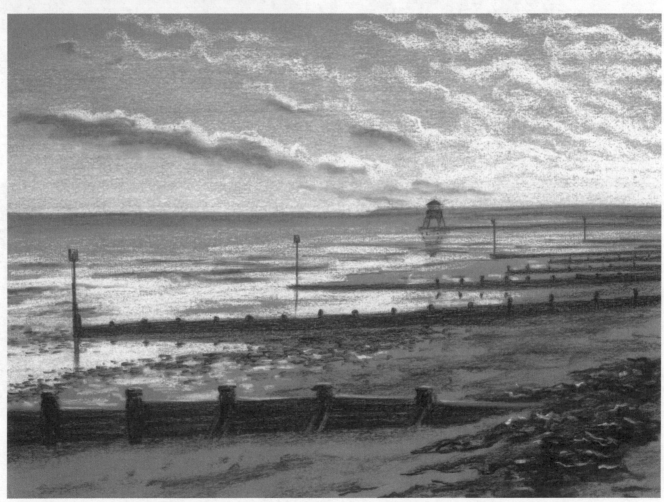

A LANDSCAPE IN PASTELS

Inspiration often strikes at inconvenient times and you may spot great subjects when you are busy or without materials. As long as you can jot down the essentials of a scene, you can work it up into a picture later. The great thing about landscapes is that once you are conversant with natural forms, textures and lighting, you can make up those details that circumstances prevent you from recording accurately.

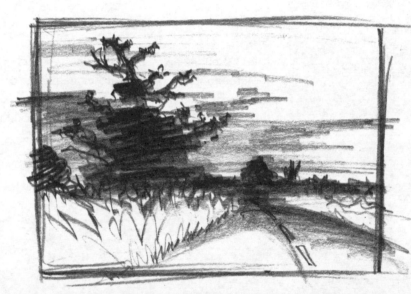

Driving in the late summer evening, I was struck by the silhouette of a dead tree and the verges illuminated by my headlights. I stopped the car, drew this rapid sketch and tried to commit as much detail as possible to memory. Once home I set about the pastel study shown on these pages, which took about an hour.

Step 1

On some cheap black craft paper I applied some sky tones in horizontal strokes, using the sides of short sticks of white and grey pastel.

Step 2

I smudged the pastels with a fingertip, then added further layers of pastel in order to build up a smoothly blended night sky.

Step 3

On top of the sky I added the next layer of the picture with charcoal, largely inventing the details of the branches and the skyline.

Step 4

Using artistic licence, I added some telegraph poles to lead the eye into the picture, and then mapped out the areas of illuminated grasses.

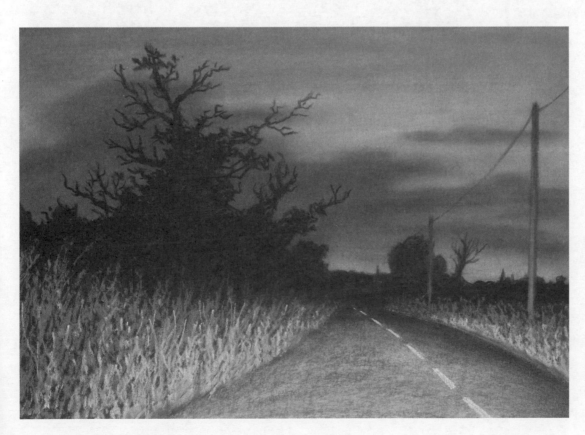

Step 5

I worked on the details and mass of the verges in grey pastel and then in white on top for an extra layer of depth. The road surface was stroked on with the side of the white pastel stick and smoothed over with my finger. I added the white lines and some highlight on the nearest telegraph pole.

81

CREATIVE FREEDOM

Up until now, the landscapes that we have worked on have been drawn from directly observable locations. As you have seen, it is important to consider your selection of subject, viewpoint and framing to bring the best out of a view. With this example, though, I worked from a mere impression of the scene and effectively invented the details. As an artist you are free to interpret your subject material in any way you choose. Ultimately, a picture is judged on its own terms, independent of the scene that inspired it.

Landscape forms lend themselves well to strong, simple designs, which can be based on observed scenes or conjured from the imagination. Try to create some of your own as exercises in simplification and composition.

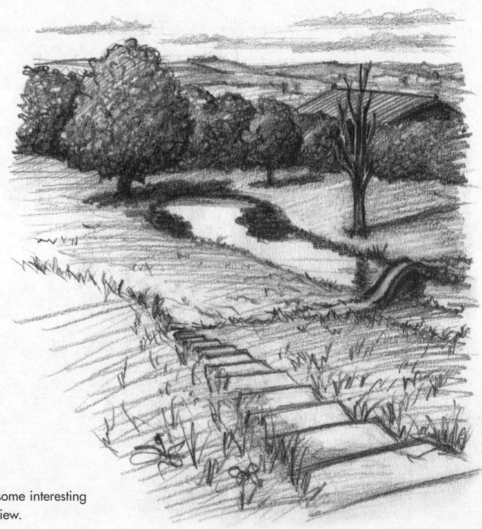

SCENE 1
I drew the above scene from life. Despite some interesting elements, it is not a particularly pleasing view.

SCENE 2

Here is a reworking of the scene, done at home. When you make such changes, remember to adjust shadows and reflections as appropriate. In practice it is unlikely that you would want to change so many elements – if it is that unsatisfactory, you would do better to look elsewhere for inspiration! My changes are merely a demonstration of the kinds of creative alterations that can be made.

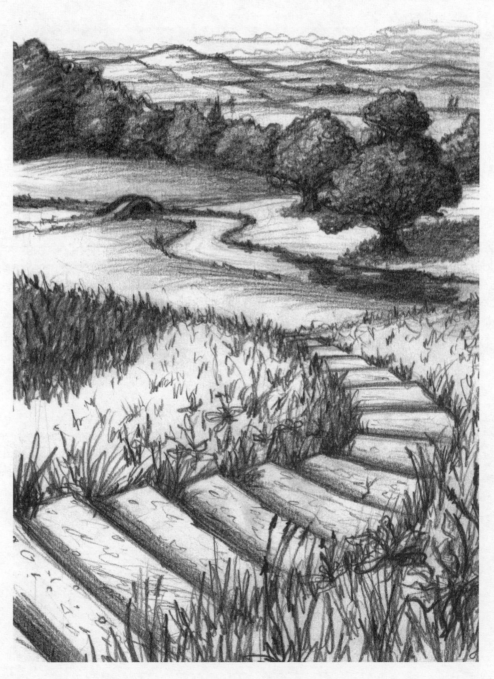

Line of trees varied

Tree removed

Bridge moved to more prominent focal point

Shadow added to balance the tones in the composition

Steps enlarged and curved to lead the eye gracefully into the picture

Height of hills exaggerated

Barn removed

Tree restored to life

Odd-shaped lake changed to a meandering river

Strong plant forms in foreground for pictorial depth

INVENTED LANDSCAPE – DILUTED INK

Sometimes the most rewarding artwork comes without any planning at all. A different approach to drawing with a brush is to paint masses and forms directly, without any prior pencil work. It is not always successful, but the process is quick enough that failed attempts do not matter. For these demonstrations I used fountain pen ink on heavy cartridge paper.

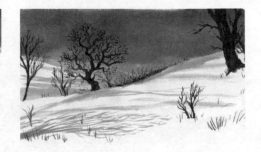

Step 1
Before I started, all I had decided was to do a snowy scene at night-time. I mixed up some ink and water in a saucer and used a large, soft brush to paint across the top third of my paper. While the ink was wet, I added a deeper tone in places and let the ink settle arbitrarily.

Step 2
With a thinner mix of ink, I then gave some form to the landscape, imagining the moonlight coming from the left. I also decided to paint the shadow of a tree across the foreground.

Step 3
Neat ink and a fine brush allowed me to draw some tree silhouettes where the landscape suggested them. A few blades of grass are always handy to suggest a covering of snow.

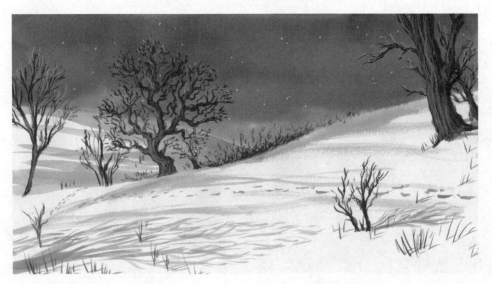

Step 4
To complete the scene, I painted the shadows of the undergrowth. I used white ink, slightly diluted, to add some texture and highlights on the trees. A few spots of neat white ink suggested stars in the night sky.

DRAWING
ANIMALS

INTRODUCTION

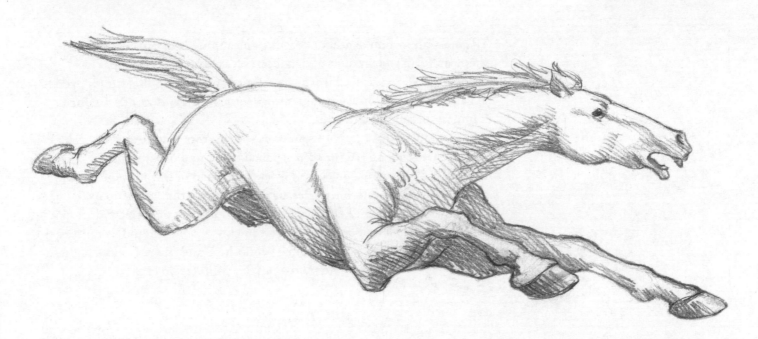

When prehistoric man first took a burnt stick and drew on the wall of his cave, it was animals that he chose to depict. To this day, the animal kingdom continues to fascinate and inspire us to create art. The subject is vast and almost unbelievably varied, offering the artist new interests and challenges at every turn.

This section of the book aims to instruct the reader in the fundamental skills of drawing animals so that, with some application, even the complete beginner should be able to produce satisfying results. Step-by-step demonstrations will teach you to capture basic animal form and then gradually increase your facilities to render shade, texture and detail. We will investigate various materials and techniques and strive to develop your own expressive drawing style along the way.

Unlike the disciplines of still life, landscape and portraiture, animals can be elusive and unpredictable and rarely keep still. For these reasons, I recommend using photographic reference for most of the exercises here – but there is much more to drawing than merely copying from pictures. Photographs are merely starting points: selection, simplification, mark-making and self-expression will make pictures that are more than mere copies.

When following the exercises, try to resist simply copying my examples; apply the same stages to photographs of your own or in books to create new pictures.

Peter Gray

85

DRAWING BASIC FORM

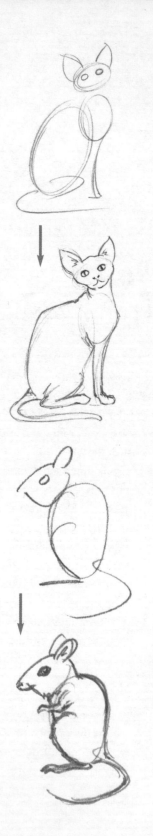

The most important aspect of drawing any animal is to capture its essential shape or 'form'; no amount of detail can save a drawing that is badly proportioned. So it is well worth spending some time on this simple exercise to gain practice in observing and drawing the weird and wonderful forms found in the animal kingdom.

Find photographs of various animals shown from simple angles, such as profiles. Use only an HB (or softer) pencil and a wad of scrap paper. Before starting each drawing, look carefully at the animal in the photograph and mentally dissect it into the circles, ovals and curves that make up its form. Forget what you might know about animals, just look at each creature as a set of abstract shapes and draw them very quickly. Then it should be quite easy to complete the outlines and add some details here and there. Do lots of these little drawings and spend no more than five minutes on each.

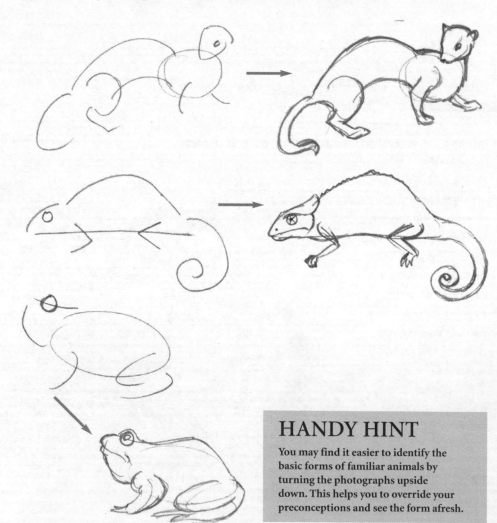

HANDY HINT

You may find it easier to identify the basic forms of familiar animals by turning the photographs upside down. This helps you to override your preconceptions and see the form afresh.

86

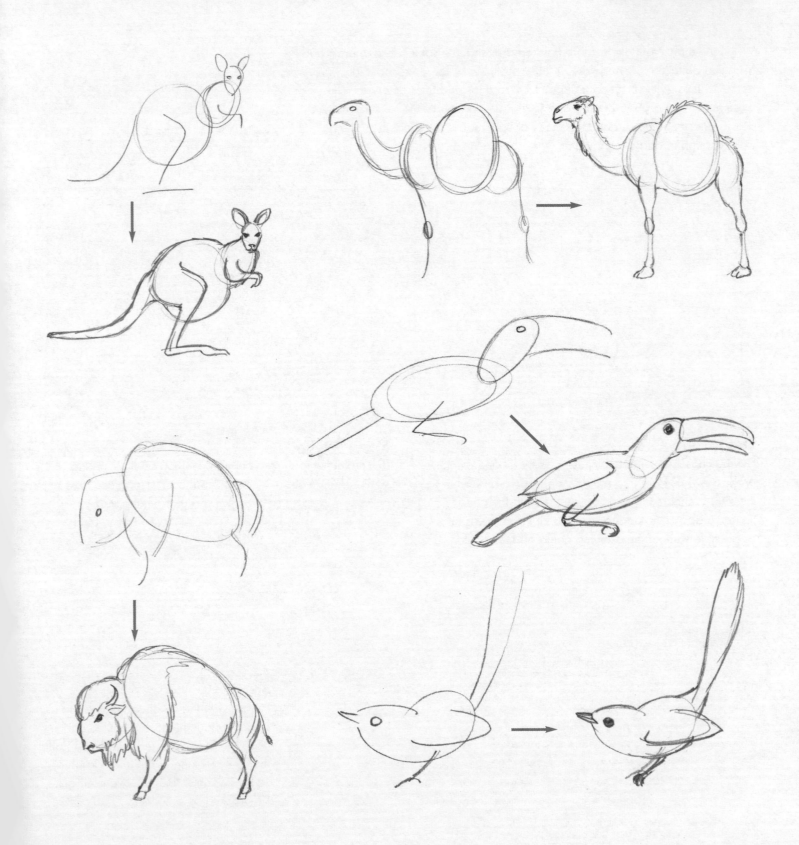

DRAWING BASIC FORM

When the aim is to make a more finished drawing, the same loose approach to form can be taken. Staying with an easy profile view for now, I have drawn a horse in steps, with attention to correct proportions and finer detail. To follow these steps, find a good photograph to use as your source. Make sure that the details are unobscured, and the quality of light makes the contours of the animal clear enough to add shading later.

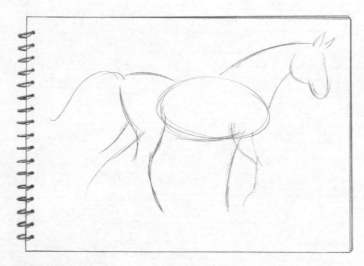

Step 1 correct

Having chosen a suitable picture, I studied it and mentally broke down its form into rough shapes. Before sketching them in, I rehearsed the rough shapes with the pencil hovering above the paper. I tried to fill the page as fully as possible without the drawing going off the edges.

Step 1 wrong

Be careful not to make your drawing too small. Working small restricts your movements and tends to produce fussy pictures. Aim for a bold drawing right from the start.

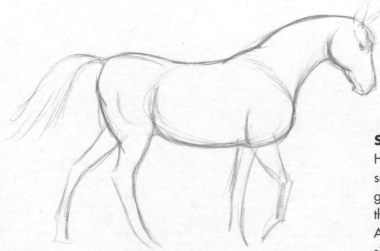

Step 2

Happy with the rough shape, I smoothed out the horse's outline and gave the legs some width and form, all the while looking at the photograph. As you do this, do not let yourself get sidetracked by any detail.

Step 3

Next I refined the head and neck so that I had a definite measurement by which to check the length of the legs. I did more work on the overall length of the legs and the positions of their joints, which I marked as oval shapes.

Step 4

It is all too easy to draw animals' legs as weak and shapeless. Drawing the joints first as sizeable masses helps in the construction of the leg's contours. At this stage, I finalized the outline of the whole drawing and also marked the shape of the mane and tail. Now the guidelines could be erased ready for shading.

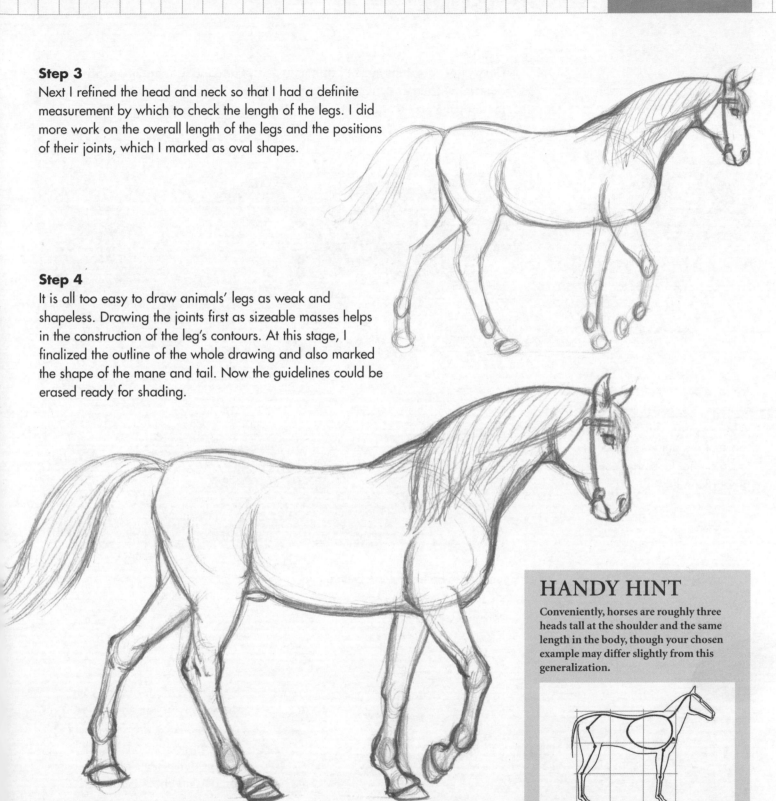

HANDY HINT

Conveniently, horses are roughly three heads tall at the shoulder and the same length in the body, though your chosen example may differ slightly from this generalization.

CHECKS AND MEASURES

Correct proportions are an important aspect of good draughtsmanship, especially when drawing animals. Some simple techniques can be very helpful for spotting errors and getting your drawings off to a good start.

Try to imagine the skeleton inside your subjects. You could even sketch it on your drawing. This helps you to get a sense of the animal's articulation and to check that limbs are consistently proportioned.

It can also be helpful to observe the 'negative shapes', the spaces in between body parts.

Regardless of the size of your drawing, you can keep a check on proportions by simple measuring. With a pencil or ruler, identify similar dimensions on your source image and check that the equivalent parts of your drawing are consistently proportioned.

If the size or placement of the drawing on your paper means that you have too little space for some features, let them run off the edge of the page. Do not squash the proportions to fit the page.

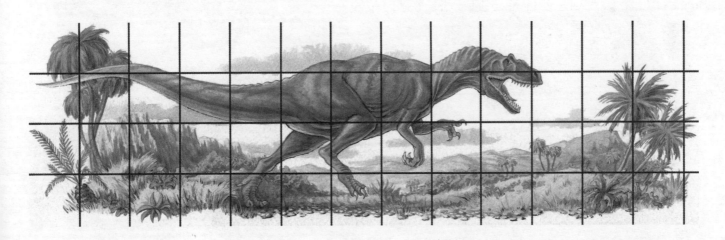

If all else fails, you can be sure of a good start by 'squaring up'. Draw a regular grid on tracing paper and place it over your source image then draw a similar grid to fit on your drawing paper. Then the picture is broken down into easily observable chunks, which may be drawn individually. This is how the old masters enlarged their drawings for murals.

NEW VIEWPOINTS

Drawing profiles is good for practice and for increasing your familiarity with different animals and their proportions, but other viewpoints reveal more about a creature's build, articulation, character, behaviour and so on. Working from photographs and breaking the subject down into abstract shapes, the process need be no more difficult.

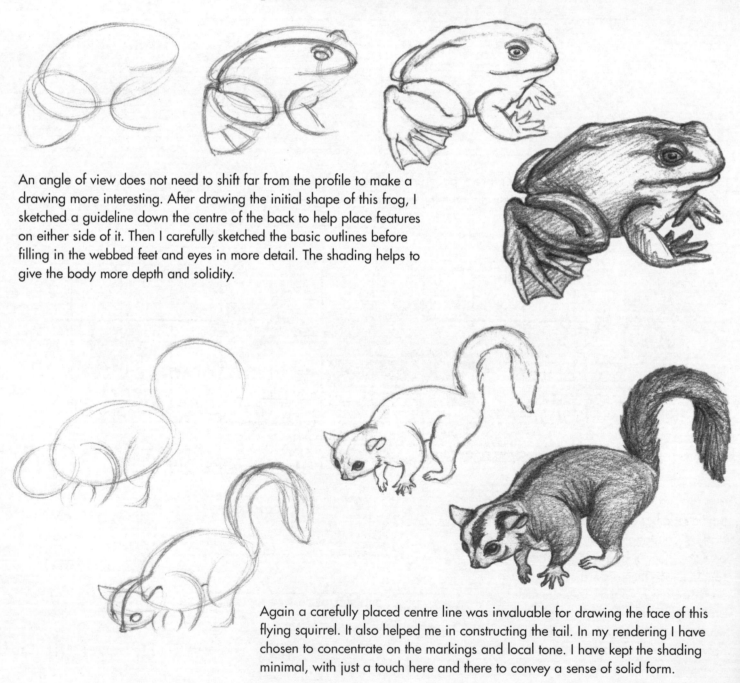

An angle of view does not need to shift far from the profile to make a drawing more interesting. After drawing the initial shape of this frog, I sketched a guideline down the centre of the back to help place features on either side of it. Then I carefully sketched the basic outlines before filling in the webbed feet and eyes in more detail. The shading helps to give the body more depth and solidity.

Again a carefully placed centre line was invaluable for drawing the face of this flying squirrel. It also helped me in constructing the tail. In my rendering I have chosen to concentrate on the markings and local tone. I have kept the shading minimal, with just a touch here and there to convey a sense of solid form.

 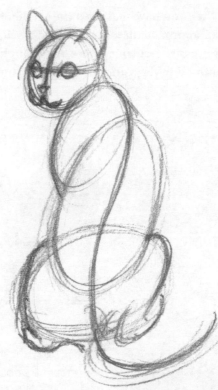 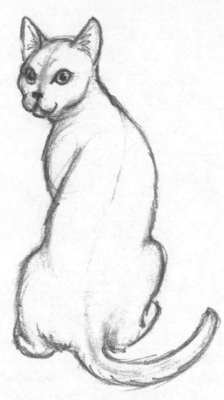

This rear view of a cat is a characterful pose that presents a rendering challenge. Lacking the distinct details of the limbs, it could easily end up as a formless blob. After the rough shapes were mapped out, I very carefully drew the centre line so that it accurately traced the path of the spine. This helped me to analyse and draw the subtle curves of the body. In rendering the drawing, the light and shade aid the description of the cat's twisting contours and follow the direction of the fur.

HANDY HINT

Sketching from ornaments and toy animals gives you the chance to study them from every angle and gain experience of complicated viewpoints.

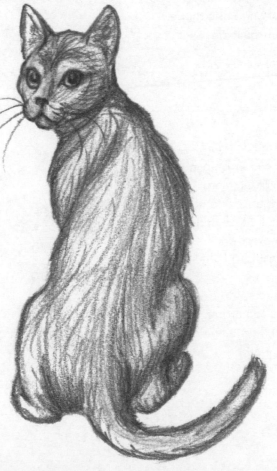

CHARCOAL AND PASTEL STUDIES

When you have mastered the art of analysing and drawing animal form you can approach the subject with sufficient confidence to make more loose and expressive drawings. Here are a couple of examples in charcoal and pastel, both done very quickly – about 20 minutes each.

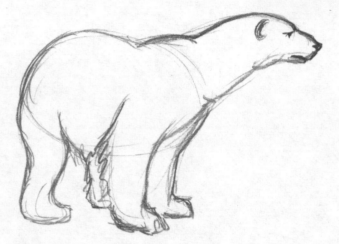

Step 1
If you are still a bit unsure of your animal drawing you could make an initial pencil drawing on scrap paper to establish a strong basic shape. Make the outline quite dark with a soft pencil.

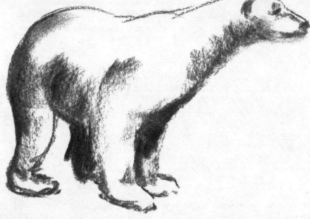

Step 2
Place a fresh sheet of paper over your rough drawing and you should be able to see the outline clearly enough to trace it. Here I used the side of a short length of charcoal to depict the areas of shade. With the tip of the charcoal I then gently traced the outline of the bear's top edge.

Step 3
To sharpen up the drawing, I used a felt-tipped brush pen to define some of the more pronounced edges and to add some details to the face and feet. Try not to overwork the outlines and details, adding them only where more clarification is necessary. With the edge of a clean eraser, I carefully cleaned up a few stray charcoal marks.

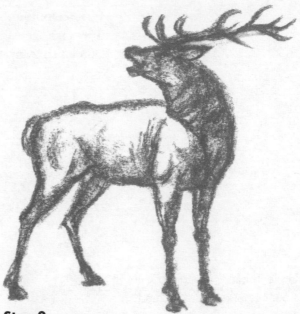

Step 1

I prefer to skip the pencil drawing and work directly in pastel. If it goes too badly wrong, I just start again. I used a mid-grey pastel here, again broken to a short stump and used on its side. As with the bear, I tried to convey shade and outline in a single motion, while setting down only the elementary form of the stag.

Step 2

With the end of the pastel, I then drew in more detail and strengthened the shading where necessary. All the while, I referred to the photographic source and corrected the form as I went along. I could happily have left the picture as a finished piece at this stage, but I thought that maybe I could bring out more character and solidity.

Step 3

I used the end of a charcoal stick to add a few details and embellishments. I also turned the charcoal on its side to deepen some areas of tone. I had to be very careful when erasing stray marks in order to avoid smudging the drawing.

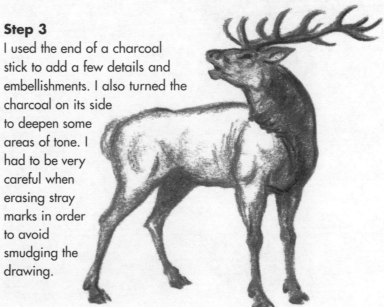

Pastels can also produce deep, rich tones and will stand heavy working over. This seagull study shows something of their potential for vigorous handling.

WATERCOLOUR STUDIES

Watercolour or diluted ink present many possibilities for rendering your drawings. Here is one very simple example and one more heavily worked one. When using any wet medium, remember to use a fairly heavy grade paper.

Step 1
For this simple treatment, I started with the barest pencil guidelines. I wanted to let the brush do the drawing.

Step 2
With a medium watercolour brush and very dilute black watercolour, I refined the outline and filled in the broad masses of shade. Before the paint dried, I used a damp brush to soften the edges and blend the tones. I then used a darker wash to paint the markings. Once dried, I erased the pencil guidelines.

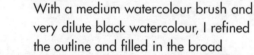

Step 3
I added selective detail here and there with a blacker mix and continued to soften the edges as I worked. A few tiny strokes of white ink brought out the highlights around the eyes.

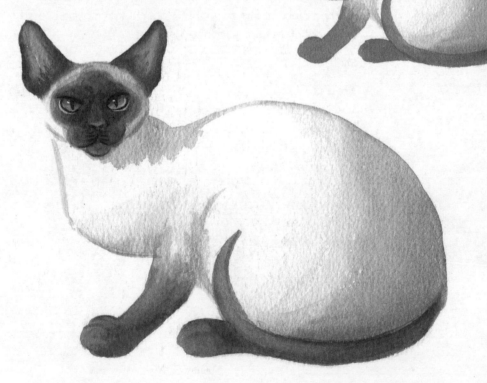

HANDY HINT

If you are impatient for washes to dry, a hairdryer will speed things up greatly.

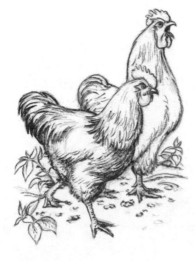

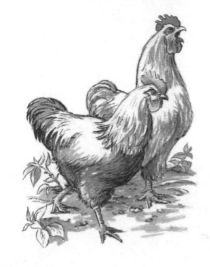

Step 1

I made this fairly detailed underdrawing based on two separate photographs. A few details of the ground help to unite the birds in a single setting.

Step 2

With black waterproof ink and a medium watercolour brush, I established firm outlines and the darker tones of the rendering. Much of the inking was done with the brush almost dry to achieve a fluffy texture.

Step 3

After erasing my pencil marks, I used a couple of layers of diluted black watercolour to fill in broad areas of shade and further develop the texture. If I chose to retain a light and loose treatment, it would take very little to finish the picture at this stage.

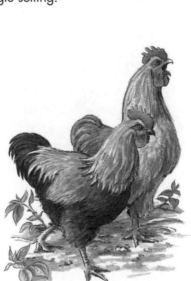

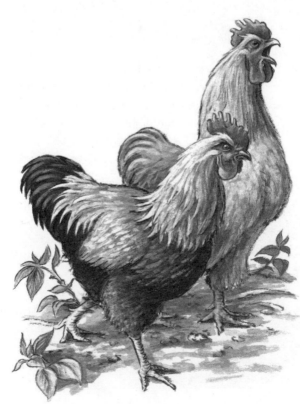

Step 4

Going for a more fully rendered approach, I used more washes of watercolour to describe the local tones of the plumage. Compared to the previous step, you can see how heavy this looks.

Step 5

So as to bring life back to the picture, I used white ink and a fine brush to add highlights and brighter accents. In some spots I applied the ink neat, while elsewhere I diluted it to paint the sheen and texture of the feathers.

TONED PAPER

There are many advantages to working on grey or coloured paper (or 'toned grounds'). The tone of the paper gives you a head start with shading, and highlights show up bright and clear. It requires a bit of advance planning to use the tone of the paper effectively, and it is important to select the appropriate shade of paper for your subject.

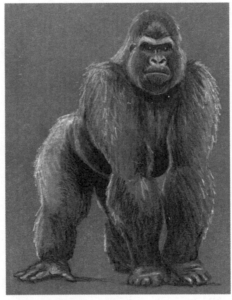

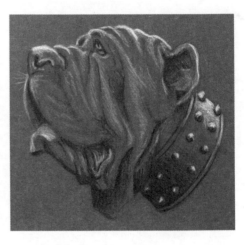

Textures like fur and feathers are quite easy to describe when drawing light on to dark. This fluffy little fellow came together quite quickly with grey and white pastels, smudged together and detailed with a spot of charcoal.

I used a very soft pencil for this gorilla and roughly shaded him following the direction of hair growth. Before I could apply the highlights, I had to erase some of the shiny graphite to allow the white pencil a clear surface to draw on.

To avoid the problem of shiny graphite, I used grey coloured pencils here for the underdrawing and rough shading. Then I could use a white pencil quite freely over it to model the dog's wrinkles, reserving the brightest marks for the lighting on top of the head.

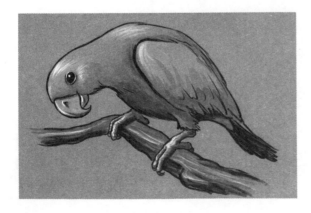

Together with the outline, the tone of the paper does most of the work in this drawing of a parakeet. Shading is just a few strokes of watercolour followed by some soft highlights of diluted white ink.

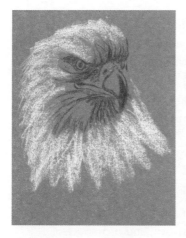

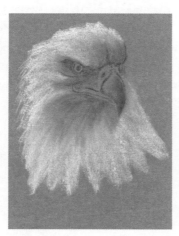

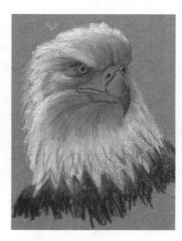

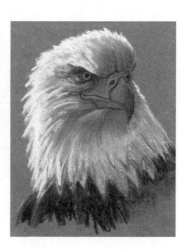

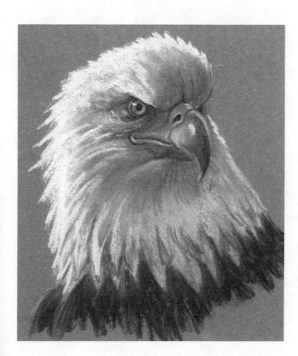

Step 1

I started this drawing by roughly sketching in the features of the face and shadowy parts with charcoal. I roughed in the shape of the head and main areas of light with the side of a short stick of white chalk.

Step 2

With the tip of a finger, I smoothed over the surface and blended the chalk and charcoal together. Already this is a strong base on to which I can work the detail.

Step 3

Here I used the charcoal again to redefine the drawing and add some textural marks to the feathers. I also brought in a hint of the shoulders to give weight to the picture and shape the neck feathers.

Step 4

Pressing down hard on the point of the chalk makes bolder marks that stand out from the smudged under-drawing, just right for the bright highlights down the side and top of the head. You can see here where my sleeve has smudged the bottom of the drawing – always a hazard to bear in mind.

Step 5

A little bit of adjustment here and there and then the fun bit. Adding the detailed highlights on the face gives the drawing a satisfying illusion of shine. Then all that remains is to tidy up any scruffy marks around the edge and give it a spray with fixative.

99

CLOSE OBSERVATION

Useful though photographs are, there is nothing like drawing from real three-dimensional objects for making clear, detailed observations and sharpening your drawing skills. It is excellent practice to sketch from stuffed animals, such as may be found in many town and city museums. These specimens provide the opportunity for the close study that live animals and photographs can rarely equal. The examples over the following few pages were all drawn on a visit to a local museum.

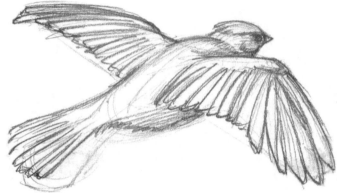

Maybe small details catch your eye, like this opossum's claws. Just as with people, animal hands can lend a great deal of character to their overall portrait so it is worth jotting down such details, which are not always easy to see in photographs.

To draw birds convincingly, the artist should know about the arrangement of their feathers, which is not always clear in photographs. Since most flighted birds have similar feather patterns, studies like this can be referred to for clarifying later drawing difficulties.

HANDY HINT

For sketching away from home I favour a hard-backed, book-bound sketchbook of about A4 size. It is small enough to carry easily, yet opens into a large, well-supported drawing surface.

The heads of big cats are very powerful and expressive. Sketches of their faces will pay off when you come to do finished drawings, and with their strong shapes they are fun to do.

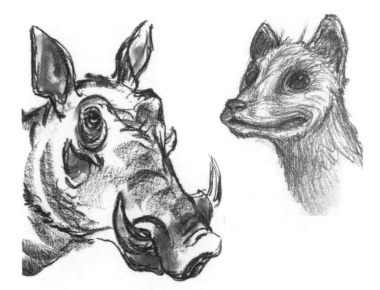

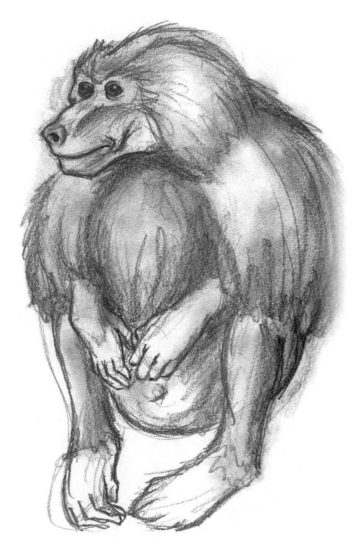

Getting close to a model allows for quite detailed drawings. In this one I wanted to record the direction of the hair growth around the head, which would be useful knowledge for future animal drawings.

I sketched this warthog for no other reason than enjoyment, as it possessed such interesting contours. Charcoal on rough paper seemed the right medium for the coarse, leathery texture. I did not bother with erasing mistakes, but simply smudged them with my finger.

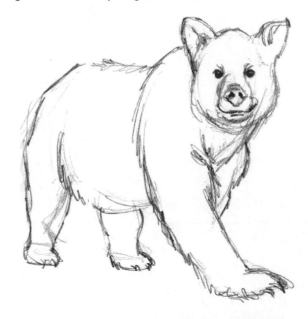

The experience of drawing from a model is very different to working from photographs. Even simple outline sketches like this provide great drawing practice.

The texture of the fur is all-important here, impressionistic rather than closely observed. I drew with a soft graphite stick and then smudged the hair with my finger for that fluffy look. Then I worked into the face with the tip of the stick for contrasting hard-edged and angular marks.

CLOSE OBSERVATION

Looking at photographs and illustrations of animals, you will soon realize how limited the angles of view are. In a museum, I was able to choose my views of this rhino, resulting in an unusual head study and a rear view. In the drawing on the right I tried to capture an impression of the texture, through a combination of mark-making and shading.

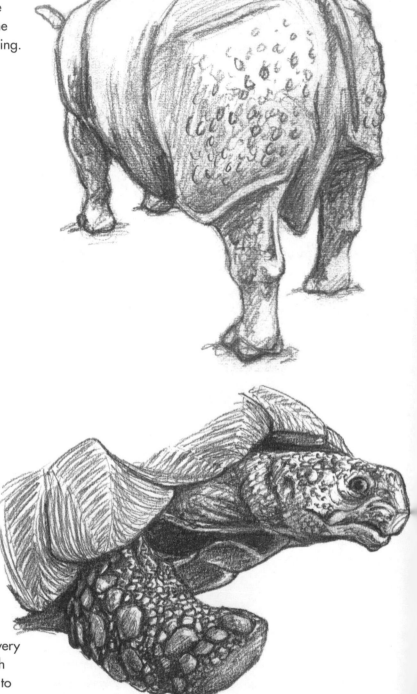

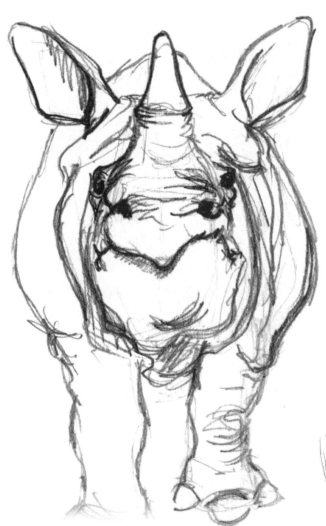

To draw the heavily textured skin of this tortoise, I used a very soft, blunted pencil, pressing down quite hard around each scale for strong definition. I then shaded over more lightly to show the play of light over the deep relief of the surfaces.

I rapidly drew and shaded these claws in HB pencil, then applied more considered textural marks and outlines with a drawing pen. This is a quick way to get a textural feeling into a sketch.

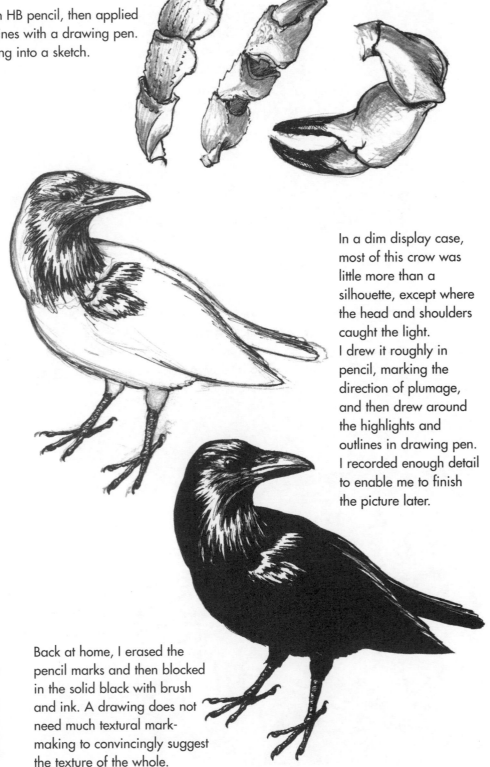

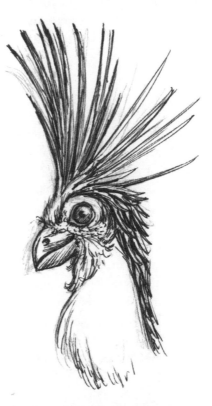

In a dim display case, most of this crow was little more than a silhouette, except where the head and shoulders caught the light. I drew it roughly in pencil, marking the direction of plumage, and then drew around the highlights and outlines in drawing pen. I recorded enough detail to enable me to finish the picture later.

The sharp line of a drawing pen was a good choice of medium for these spiky feathers. I used pencil to establish the general shape and then drew the detail directly with the pen, making my marks deliberately harsh and jagged where appropriate.

HANDY HINT

Visit museums at quiet times when children are at school, otherwise you may be interrupted or create an obstacle to others. You may need to obtain permission to draw before you start.

Back at home, I erased the pencil marks and then blocked in the solid black with brush and ink. A drawing does not need much textural mark-making to convincingly suggest the texture of the whole.

DRAWING FROM LIFE

Drawing from stuffed models is good preparation for facing one of the great challenges – live animals. It is useful to adopt the right mindset. The practice is usually limited to depicting impressions and gaining familiarity with your subjects rather than making finished pictures in one sitting. Think of your sketchbook as a personal journal that nobody else ever need see, a space in which to gather information, and also to make errors and false starts and chart your artistic development.

Erratic though they may be, there are many circumstances in which animals may remain relatively static and give you a good introduction to drawing from life. But even sedate creatures will not remain still for long, so it requires quick responses and a willingness to abandon drawings when the model ceases to cooperate.

If an animal is tired or bored it is unlikely to move too much, but make sure that your drawing activity does not excite its interest. I sketched the bulldog on the far left at a dog show, late in the day after it had been waiting around for hours. The labrador was a young guide dog, selected for its placid temperament. It lay on a café floor and didn't move a muscle while I drew.

In a zoo, the animals will often sit motionless for long periods. For drawing the iguana enclosure I used a permanent ink brush pen and watered-down ink applied with a broad bristle brush.

The parrots were drawn very quickly with charcoal. I then scrubbed on some water-soluble crayon and blended the tones with brush and water.

Food is always good for keeping animals in one place. I observed this lioness vigorously tugging at some meat, then drew most of the picture without looking up. With the basic shape in place, I could then refer to the moving animal and glean enough information to add details. It is not an accurate drawing, but it does have something of the creature's attitude.

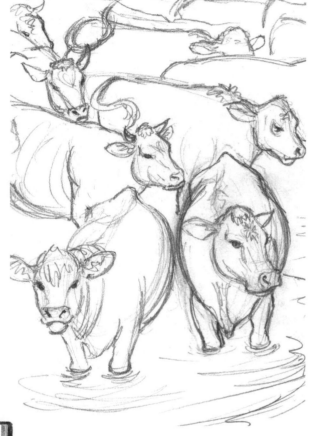

On a hot day, these cows stood for a long time in a pond to keep cool. I attempted to draw them as a scene, roughly drawing the foreground animals first and working backwards, filling in the gaps. The cows' heads moved a lot and I had to keep turning my attention from one to another.

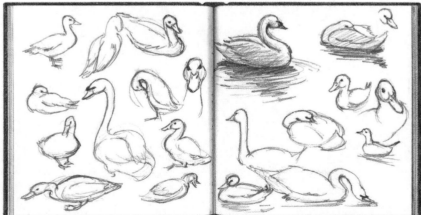

Water birds do not remain static, making close study difficult. A good way to draw them is to work on several pictures at the same time. As one bird moves, abandon the drawing and work on another. Soon another bird will adopt a similar position for long enough for you to complete the first sketch.

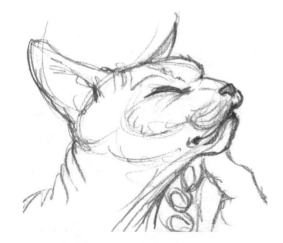

An excitable pet can often be made to sit still for a short time if it is stroked and petted.

105

CHARACTER AND EXPRESSION

As well as the great diversity of species, individuals within a species often display their own traits and features. Getting to know pets, we soon notice their individual characteristics, expressions and funny little ways. Capturing a 'portrait' of a specific animal can be a subtle yet rewarding challenge.

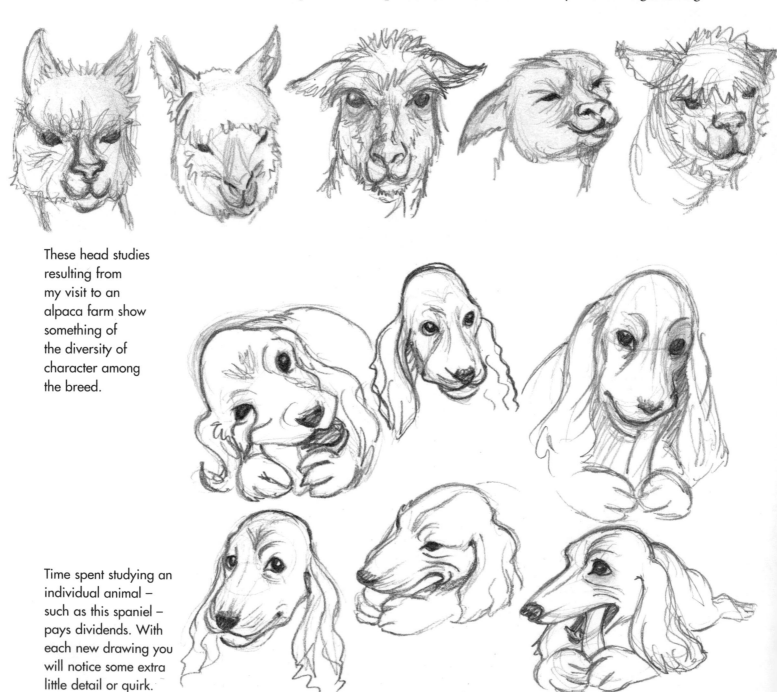

These head studies resulting from my visit to an alpaca farm show something of the diversity of character among the breed.

Time spent studying an individual animal – such as this spaniel – pays dividends. With each new drawing you will notice some extra little detail or quirk.

DRAWING
FIGURES

INTRODUCTION

From the mid-1500s onwards, composition was considered to be the most prestigious area of art, which made it of primary interest to the greatest artists of the time. Of course they were skilled in all areas of drawing and painting, but when the great art workshops, or bottegas, of the Renaissance period were in full swing it was often the master painter who would be the only artisan to put in the figures, leaving the rest of the composition to be completed by his pupils. So be prepared for the most interesting and most difficult subject you will tackle as a draughtsman – but do not feel too daunted. I have found in many years of teaching that anyone can learn to draw anything competently, with the combination of a certain amount of hard work and the desire to achieve success.

The aim of this part of the book is to explore all the practices necessary to achieve a good level of drawing of the human figure. I shall first look at how the human body is formed, from its skeleton – the scaffolding that all figures are based on – down to the details of the limbs, the torso, the hands and feet and the head. It is always useful to have some idea as to the body formation beneath the skin, and some knowledge of how the muscles wrap around the bone structure and each other is of great use when you look at the shapes on the surface of the body. Without any knowledge of the underlying structure it is much harder to make sense of the bumps and furrows that are visible.

I shall also look at the balance of the limbs when the body is in motion, and how the artist can produce the effect of movements that appear natural and convincing to the viewer of the picture.

The techniques of drawing will also be examined, and the ways in which different artists have made efforts to show us how the human figure can be portrayed, from the most detailed to the most expressive. Of course this section does not pretend to be exhaustive, since figure drawing has been developed and explored over centuries as artists sought new ways of portraying the human form. Nevertheless, enjoy this foray into the challenging but fulfilling task of portraying the human figure, and revel in the development of your own ability as an artist.

Barrington Barber

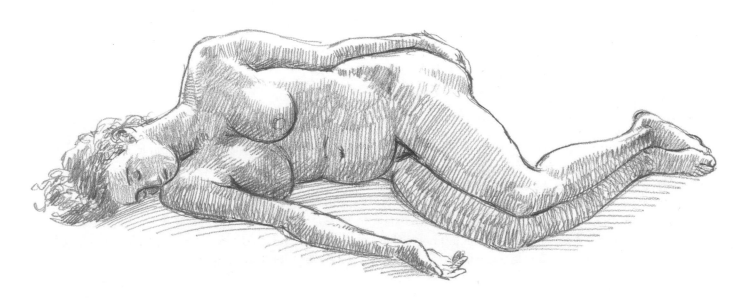

PROPORTIONS OF THE HUMAN FIGURE

Generally, the female body is slightly smaller and finer in structure than that of a male, but of course sizes differ so much that you will have to use your powers of observation when drawing any individual. In the examples below, the man's shoulders are wider than the woman's and the woman's hips are wider than the man's. This is, however, a classic proportion, and in real life people are often less perfectly formed. Nonetheless, this is a good basic guide to the shape and proportion of the human body.

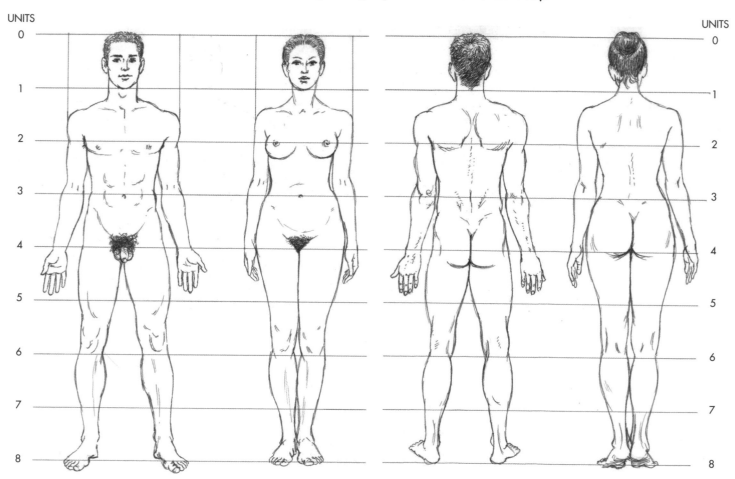

These drawings assume the male and female are both exactly the same height, with both sexes having a height of eight times the length of their head. Note where the other units of head length are placed: the second unit is at the armpits, the third is at the navel, the fourth at the groin, the fifth mid-thigh, the sixth below the knee joint and the seventh just below the calf. This is a very useful scale to help you get started.

The man's neck is thicker in relation to his head while the female neck is more slender. The female waist is narrower than the man's and the general effect of the female figure is smoother and softer than the man's more hard-looking frame. In the main the differences are connected with childbirth and child rearing; women's hips are broader than men's for this reason too.

Proportions of children

The proportions of children's bodies change very rapidly and because they grow at very different speeds what is true of one child at a certain age may not be true of another. Consequently, the drawings here can only give an average guide to children's changes in proportion as they get older. The child's head is much smaller than an adult's and only achieves adult size at around 16 years old. The most obvious difference between a child, an adolescent and an adult is that the limbs and body become more slender as part of the growing process. In some types, the tendency towards puppy fat makes them look softer and rounder. Boys and girls often look similar until they reach puberty.

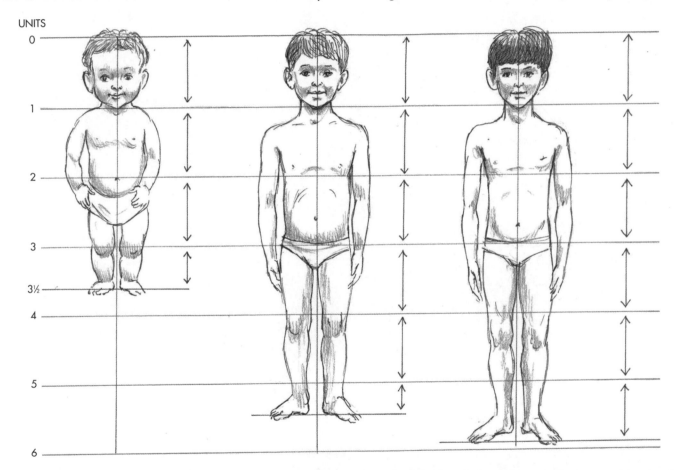

UNITS
0
1
2
3
3½
4
5
6

At the beginning of life the head is much larger in proportion to the rest of the body than it will be later on. The child on the left is about 18 months old and shows the proportion you might find in a child of average growth. The height is only three and a half times the length of the head, which means that the proportions of the arms and legs are much smaller in comparison to those of an adult.

At the age of about six or seven, as shown in the drawing in the middle, a child's height is a little over five times the length of the head, though again this is variable. At about 12 years (right), the proportion is about six times the head size. Notice how in the younger children the halfway point in the height of the body is much closer to the navel, but this gradually lowers until it reaches the adult proportion. The relative width of the body and limbs in relation to the height gradually becomes slimmer so that a very small child looks very chubby and round, whereas a 12-year-old can look extremely slim for their height.

THE SKELETON

Learning the names of the bones that make up the human skeleton and how they connect to each other throughout the body may seem rather a dry exercise, but they constitute the basic scaffolding that the body is built on and having some familiarity with this element of the human frame will really help you to understand the figures you draw.

FRONT VIEW

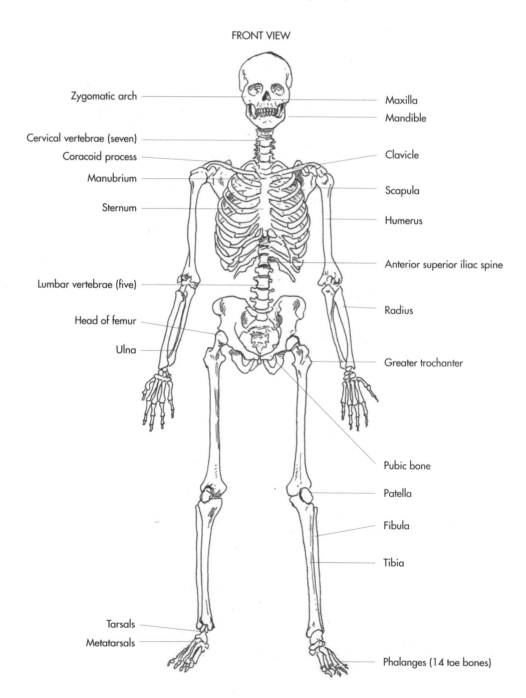

Zygomatic arch

Cervical vertebrae (seven)
Coracoid process
Manubrium
Sternum

Lumbar vertebrae (five)

Head of femur
Ulna

Tarsals
Metatarsals

Maxilla
Mandible

Clavicle

Scapula

Humerus

Anterior superior iliac spine

Radius

Greater trochanter

Pubic bone

Patella

Fibula

Tibia

Phalanges (14 toe bones)

Just making the attempt to copy a skeleton, especially if you get a really close-up view of it, will teach you a lot about the way the body works. It is essential that you can recognize those places where the bone structure is visible beneath the skin and by inference get some idea about the angle and

form of the bones even where you cannot see them. Most school science laboratories have carefully made plastic skeletons to draw from, or if you know an artist's studio or art school where there is a real one, that is even better. It will be time well spent.

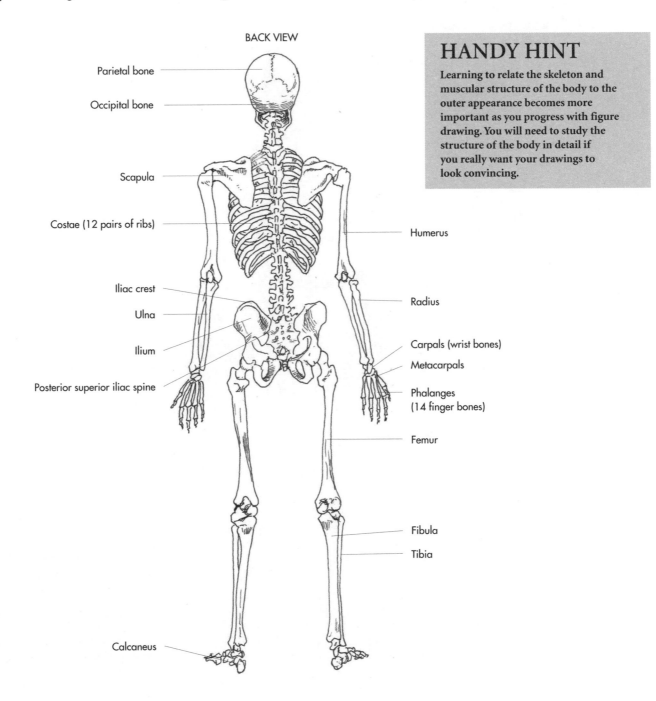

BACK VIEW

Parietal bone

Occipital bone

Scapula

Costae (12 pairs of ribs)

Iliac crest

Ulna

Ilium

Posterior superior iliac spine

Humerus

Radius

Carpals (wrist bones)

Metacarpals

Phalanges
(14 finger bones)

Femur

Fibula

Tibia

Calcaneus

HANDY HINT

Learning to relate the skeleton and muscular structure of the body to the outer appearance becomes more important as you progress with figure drawing. You will need to study the structure of the body in detail if you really want your drawings to look convincing.

MUSCULATURE

After studying the skeleton, the next logical step is to examine the muscular system. This is more complicated, but there are many good books showing the arrangement of all the muscles and how they lie across each other and bind around the bone structure, giving us a much clearer idea of how the human body gets its shape.

FRONT VIEW

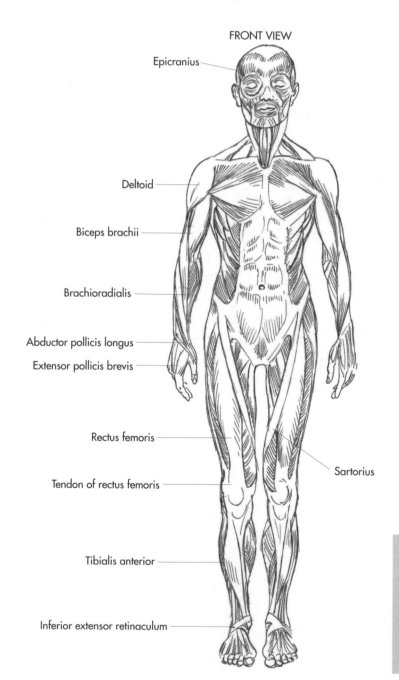

Epicranius

Deltoid

Biceps brachii

Brachioradialis

Abductor pollicis longus

Extensor pollicis brevis

Rectus femoris

Sartorius

Tendon of rectus femoris

Tibialis anterior

Inferior extensor retinaculum

HANDY HINT

It is a good idea to study a diagram like this and then try to find as many muscles as you can visible on the surface of your own body. This connection between your own muscles and the general design of the human figure really does help to inform your subsequent drawing.

As artists, our primary interest is in the structure of the muscles on the surface. There are two types of muscles that establish the main shape of the body and they are either striated or more like smooth cladding. The large muscles are the most necessary ones for you to know and once you have familiarized yourself with these it is only really necessary to investigate the deeper muscle structures for your own interest. If you can remember the most obvious muscles, that is good enough for the purposes of drawing figures.

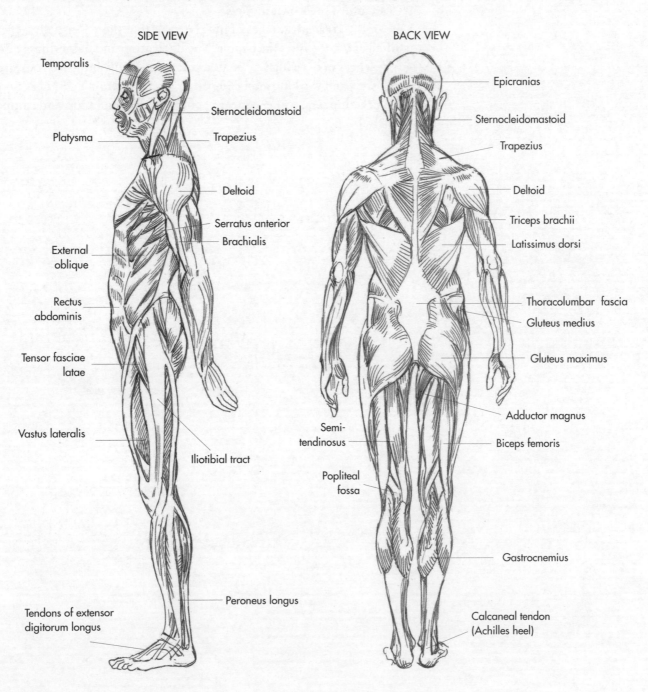

SIDE VIEW

Temporalis

Platysma

External oblique

Rectus abdominis

Tensor fasciae latae

Vastus lateralis

Tendons of extensor digitorum longus

Sternocleidomastoid

Trapezius

Deltoid

Serratus anterior

Brachialis

Iliotibial tract

Peroneus longus

BACK VIEW

Epicranias

Sternocleidomastoid

Trapezius

Deltoid

Triceps brachii

Latissimus dorsi

Thoracolumbar fascia

Gluteus medius

Gluteus maximus

Adductor magnus

Semi-tendinosus

Biceps femoris

Popliteal fossa

Gastrocnemius

Calcaneal tendon (Achilles heel)

DRAWING FROM LIFE

Drawing from life is the foundation of all drawing and of course this is particularly so in the case of figure drawing. The human body is the most subtle and difficult thing to draw and you will learn more from a few lessons in front of a model than you ever could drawing from photographs. Even professional artists will attend life drawing classes whenever possible, unless they can afford their own models.

One of the great advantages of life classes is that there is usually a highly qualified artist teaching the course. The dedication and helpfulness of most of these teachers of drawing will enable you to gradually improve your drawing step by step, and working alongside other students, from beginners to quite skilful practitioners, will encourage your work by emulation and competition.

An exercise in steps

For a beginner first embarking on drawing the whole figure, the tendency is to become rather tense about the enormity of the task and the presence of a real live model. To begin with, just take it step by step. You can stop your drawing at any stage – there is no need to feel that you have to press on to a conclusion that you are not sufficiently ready for. Start very simply, for example with a seated male figure, as shown here.

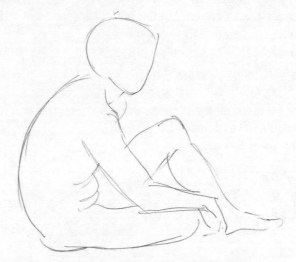

Step 1 The first stage is to see the very basic shape that the disposition of the body and limbs make in the simplest geometric way.

Step 2 The next stage is to make the shape more like the actual volume of the figure by drawing curved outlines around each limb and the head and torso.

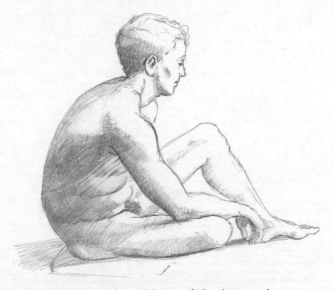

Step 3 The next step is to block in the changes in the planes of the surface as shown by the light and shade on the body.

Step 4 Lastly comes the addition of shading so that the three-dimensional aspect of the figure begins to make itself evident.

FIGURES IN PERSPECTIVE

To examine foreshortening at its most exaggerated, the model should be lying down on the ground or a low platform or bed. Position yourself so that you are looking from one end of the body along its length and you will have a view of the human figure in which the usual proportions are all changed. Because of the laws of perspective, the parts nearest to you will look much larger than the parts farther away.

Once you feel confident with the early stages of getting figures down on paper, you are ready to tackle the bigger challenge of seeing the figure in perspective where the limbs and torso are foreshortened and do not look at all like the human body in conventional pose.

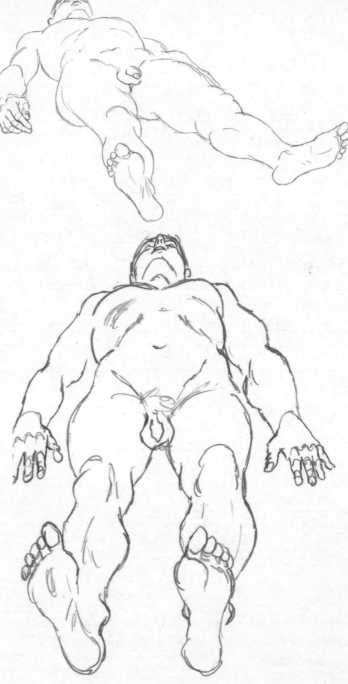

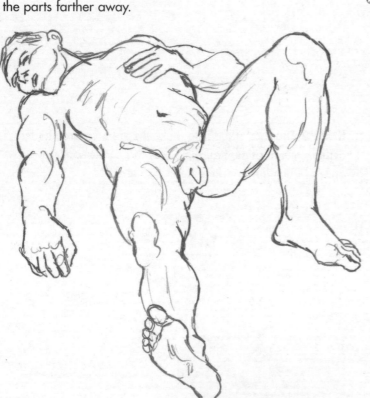

Looking at the figure from the feet end, the feet and legs look enormous and the chest and head almost disappear in relation to them.

Sometimes the shoulders cannot be seen and the head is just a jutting jaw with the merest suggestion of a mouth, an upwardly pointing nose and the eyes, brows and hair reduced to almost nothing.

116

Standing at the head end, you will find that everything has to be reassessed again. This time the head is very large but you can mostly see just the top of it and the shoulders and chest or shoulder blades, which bulk large.

As the eye travels down towards the legs, the most noticeable thing is how short and stubby they look from this angle. The feet may stick up if the model is on his or her back, but the legs themselves are just a series of bumps of thighs, knees and calves.

Try measuring the difference between the legs and the torso and you will find that although you know the legs are really half the length of the whole figure, from this angle they are more like a quarter of the full length. Not only that, the width of the shoulders and hips are vastly exaggerated so that the body looks very short in relation to its width. Most students new to this view of the figure draw it far too long for its width. Make sure you observe the figure carefully to avoid this.

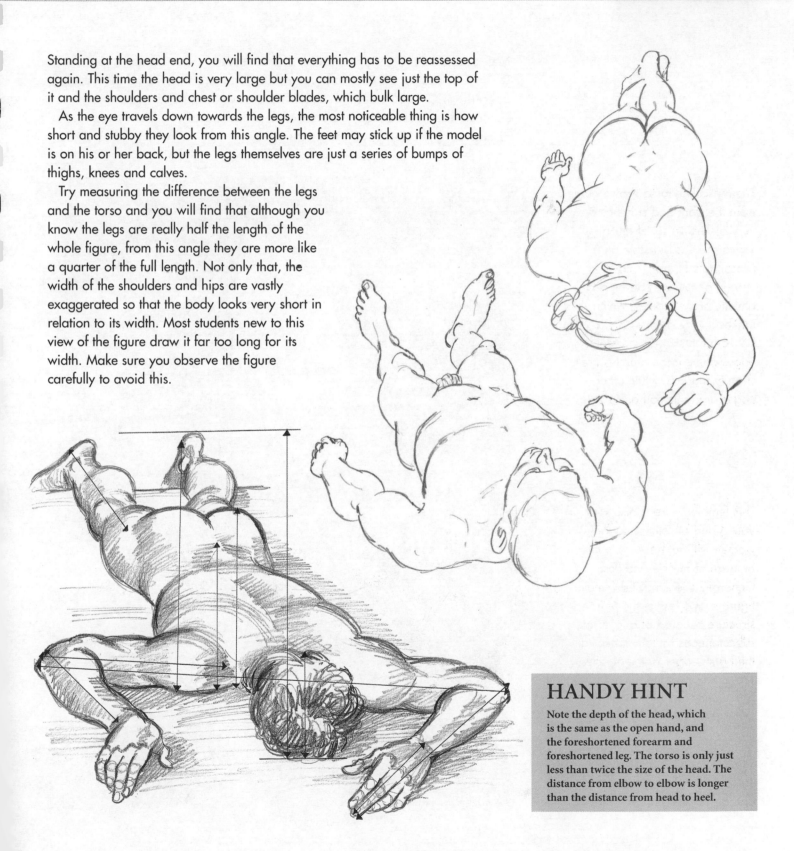

HANDY HINT

Note the depth of the head, which is the same as the open hand, and the foreshortened forearm and foreshortened leg. The torso is only just less than twice the size of the head. The distance from elbow to elbow is longer than the distance from head to heel.

THE TORSO

Male and female torsos present very different surfaces for the artist to draw. Because most men are more muscular than women, light will fall differently upon the angles and planes of the body. In the case of the female torso, the shadowed areas are longer and smoother, as the planes of the body are not disrupted by such obvious musculature.

The masculine torso shown here from the front and side has a very distinctive set of muscles, which are easily visible on a reasonably fit man. I have chosen a very well developed athletic body to draw, which makes it very clear what lies beneath the skin. Some of the edges of the large muscles are sharply marked, while other edges are quite soft and subtle.

This female figure is also very young and athletic and many women will not have quite this balance of muscle and flesh. Generally speaking, the female figure shows less of the muscle structure because of a layer of subcutaneous fat that softens all the harsh edges of the muscles. This is why women always have a tendency to look rounder and softer than men do.

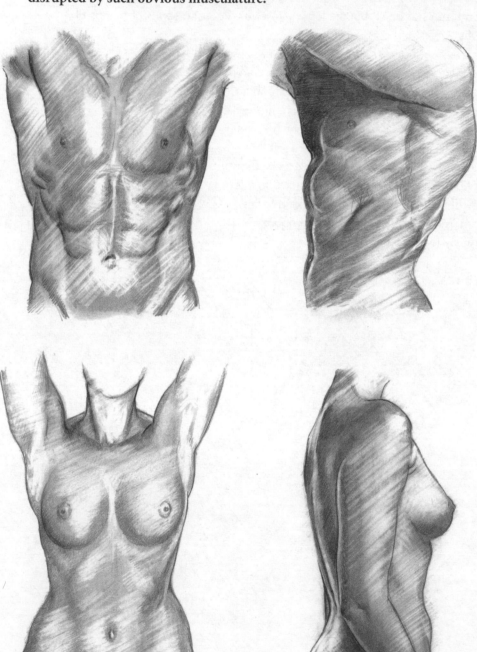

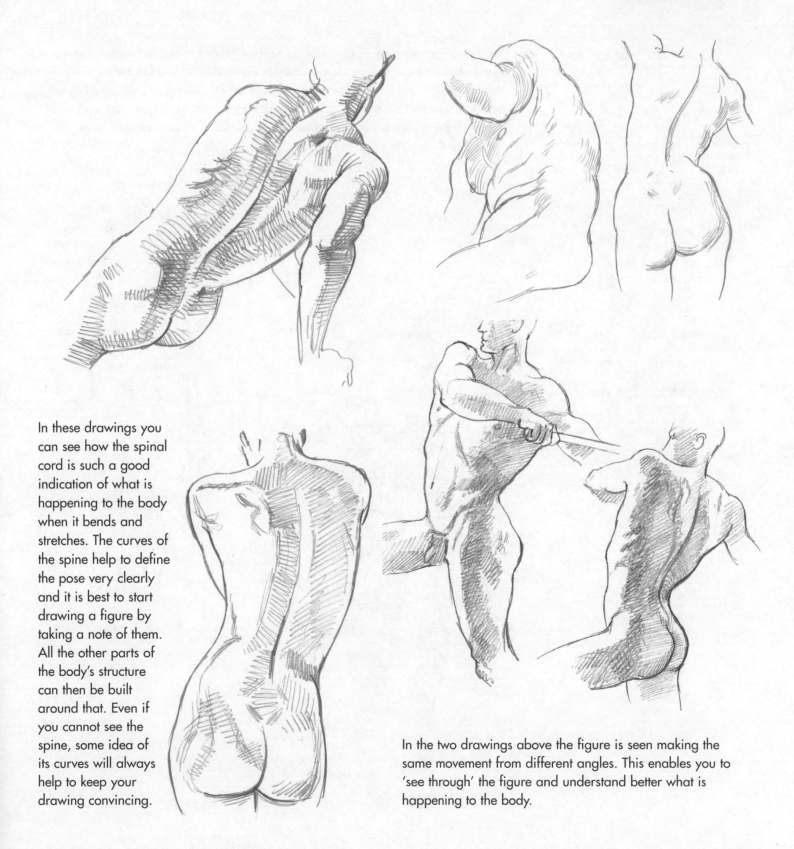

In these drawings you can see how the spinal cord is such a good indication of what is happening to the body when it bends and stretches. The curves of the spine help to define the pose very clearly and it is best to start drawing a figure by taking a note of them. All the other parts of the body's structure can then be built around that. Even if you cannot see the spine, some idea of its curves will always help to keep your drawing convincing.

In the two drawings above the figure is seen making the same movement from different angles. This enables you to 'see through' the figure and understand better what is happening to the body.

LEGS

FRONT UPPER LEG MUSCLES

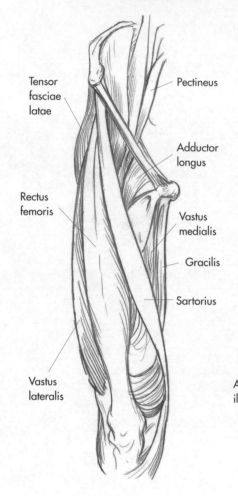

Tensor
fasciae
latae

Pectineus

Adductor
longus

Rectus
femoris

Vastus
medialis

Gracilis

Sartorius

Vastus
lateralis

Studying the anatomy of the limbs is never a wasted exercise: the more you understand about the muscles and bones beneath the skin, the better your drawings will be. Like the arms (see pages 124–5), the legs are wrapped in long, layered muscles that help to give flexibility. However, because of the increased strength needed to support the body's weight, the leg muscles tend to be longer and bigger.

BACK UPPER LEG MUSCLES

UPPER LEG BONES

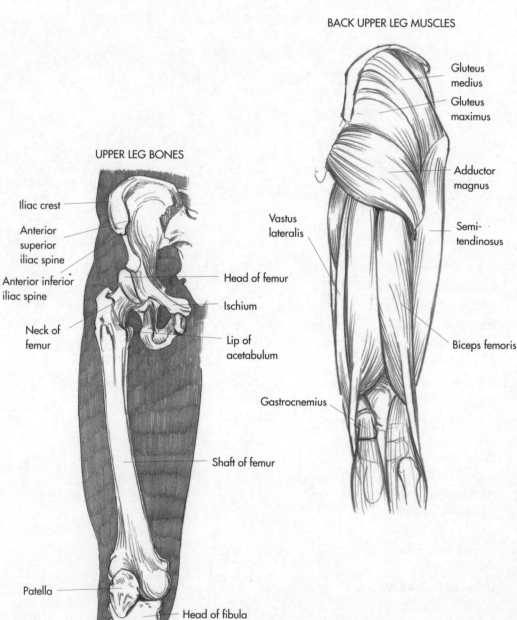

Iliac crest

Anterior
superior
iliac spine

Anterior inferior
iliac spine

Neck of
femur

Head of femur

Ischium

Lip of
acetabulum

Shaft of femur

Patella

Head of fibula

Gluteus
medius

Gluteus
maximus

Adductor
magnus

Vastus
lateralis

Semi-
tendinosus

Biceps femoris

Gastrocnemius

120

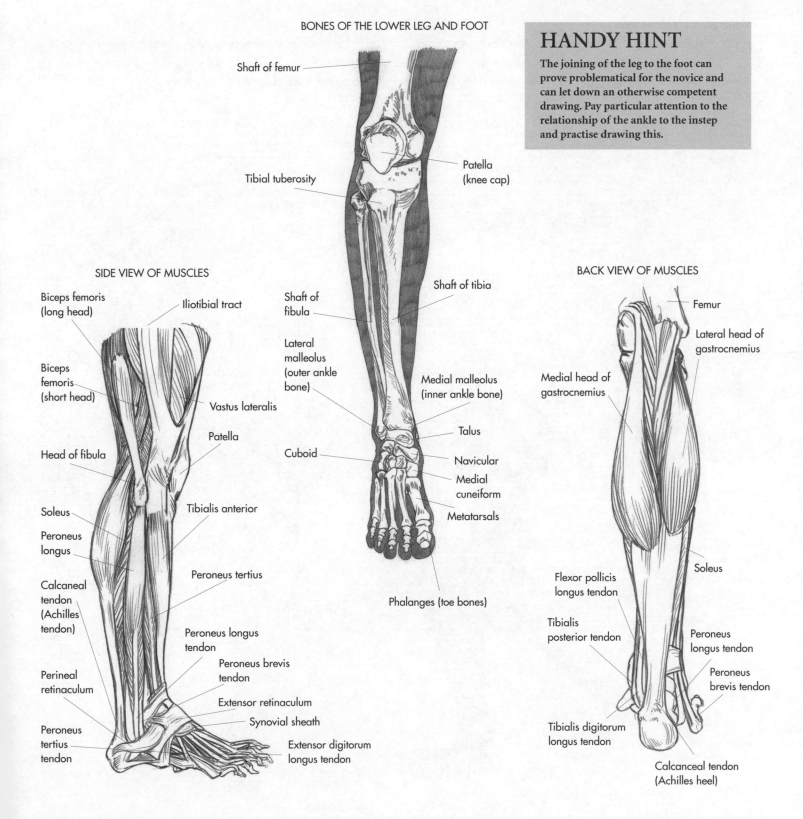

BONES OF THE LOWER LEG AND FOOT

Shaft of femur

Patella
(knee cap)

Tibial tuberosity

HANDY HINT

The joining of the leg to the foot can prove problematical for the novice and can let down an otherwise competent drawing. Pay particular attention to the relationship of the ankle to the instep and practise drawing this.

SIDE VIEW OF MUSCLES

Biceps femoris
(long head)

Iliotibial tract

Shaft of
fibula

Shaft of tibia

Biceps
femoris
(short head)

Lateral
malleolus
(outer ankle
bone)

Medial malleolus
(inner ankle bone)

Vastus lateralis

Patella

Head of fibula

Talus

Soleus

Cuboid

Navicular

Tibialis anterior

Medial
cuneiform

Peroneus
longus

Metatarsals

Peroneus tertius

Calcaneal
tendon
(Achilles
tendon)

Phalanges (toe bones)

Peroneus longus
tendon

Perineal
retinaculum

Peroneus brevis
tendon

Extensor retinaculum

Peroneus
tertius
tendon

Synovial sheath

Extensor digitorum
longus tendon

BACK VIEW OF MUSCLES

Femur

Lateral head of
gastrocnemius

Medial head of
gastrocnemius

Soleus

Flexor pollicis
longus tendon

Tibialis
posterior tendon

Peroneus
longus tendon

Peroneus
brevis tendon

Tibialis digitorum
longus tendon

Calcaneal tendon
(Achilles heel)

121

Complete side views

From the side, you will see that the muscles in the thigh and the calf of the leg show up most clearly, the thigh mostly towards the front of the leg and the calf toward the back.

The large tendons show mostly at the back of the knees and around the ankle. Notice the way the kneecap changes shape as the knee is bent or straightened.

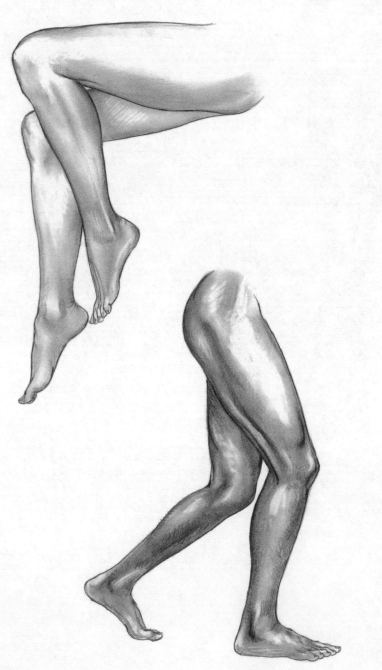

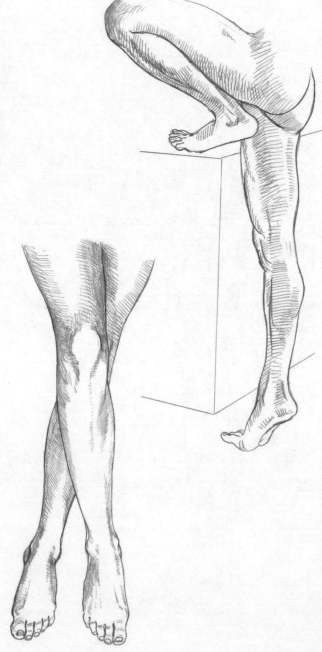

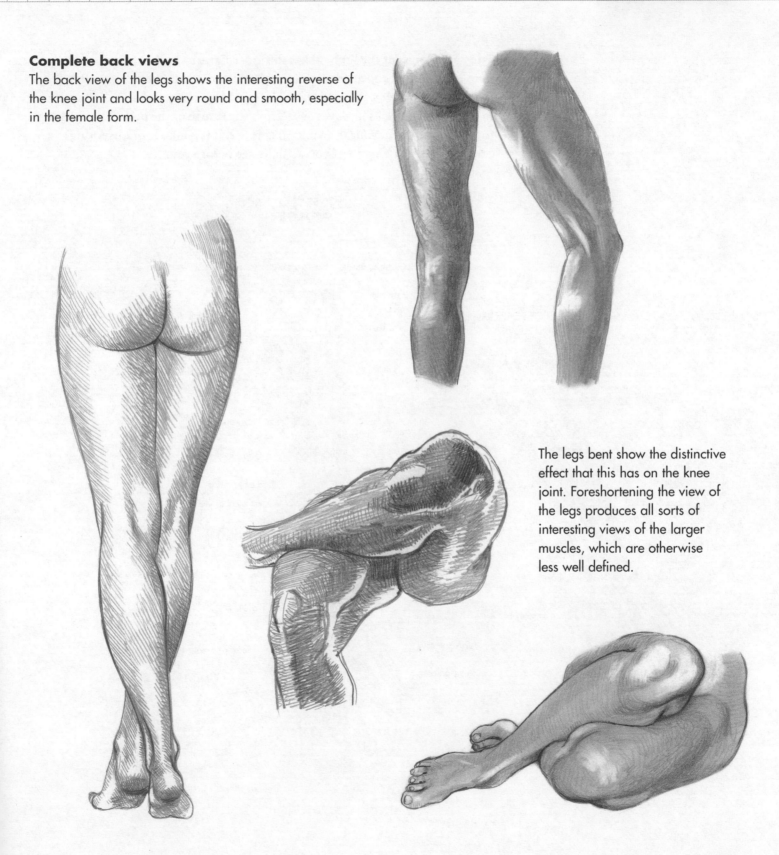

Complete back views
The back view of the legs shows the interesting reverse of the knee joint and looks very round and smooth, especially in the female form.

The legs bent show the distinctive effect that this has on the knee joint. Foreshortening the view of the legs produces all sorts of interesting views of the larger muscles, which are otherwise less well defined.

ARMS

The narrowness of the limb makes the musculature show much more easily than in the torso, and at the shoulder, elbow and wrist it is even possible to see the end of the skeletal structure. This tendency of bone and muscle structure to diminish in size as it moves away from the centre of the body is something that should inform your drawings. As always, it is a matter of observing carefully and drawing what you actually see before you.

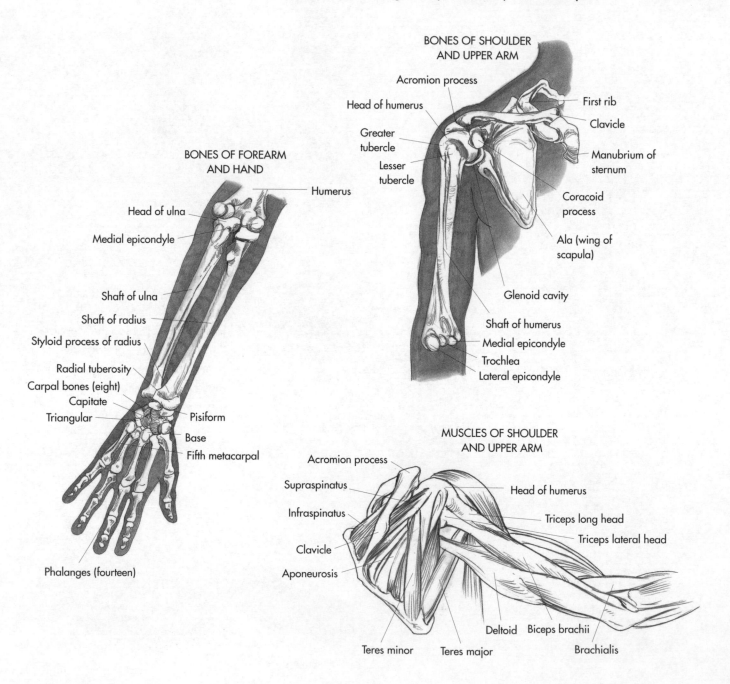

BONES OF SHOULDER
AND UPPER ARM

Acromion process

Head of humerus

Greater
tubercle

Lesser
tubercle

First rib

Clavicle

Manubrium of
sternum

Coracoid
process

Ala (wing of
scapula)

Glenoid cavity

Shaft of humerus

Medial epicondyle

Trochlea

Lateral epicondyle

BONES OF FOREARM
AND HAND

Humerus

Head of ulna

Medial epicondyle

Shaft of ulna

Shaft of radius

Styloid process of radius

Radial tuberosity

Carpal bones (eight)

Capitate

Triangular

Pisiform

Base

Fifth metacarpal

Phalanges (fourteen)

MUSCLES OF SHOULDER
AND UPPER ARM

Acromion process

Supraspinatus

Infraspinatus

Clavicle

Aponeurosis

Head of humerus

Triceps long head

Triceps lateral head

Teres minor

Teres major

Deltoid

Biceps brachii

Brachialis

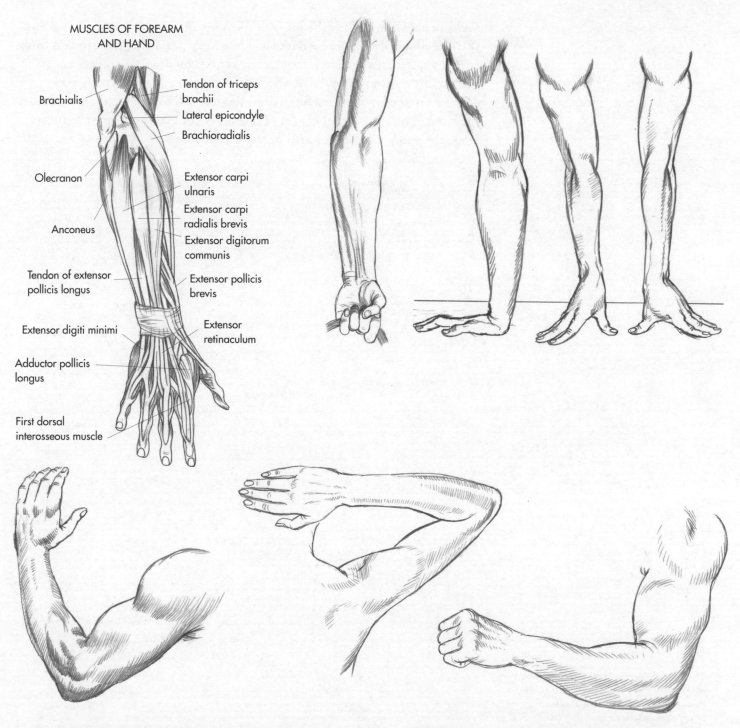

MUSCLES OF FOREARM
AND HAND

Brachialis

Tendon of triceps
brachii

Lateral epicondyle

Brachioradialis

Olecranon

Extensor carpi
ulnaris

Extensor carpi
radialis brevis

Anconeus

Extensor digitorum
communis

Tendon of extensor
pollicis longus

Extensor pollicis
brevis

Extensor digiti minimi

Extensor
retinaculum

Adductor pollicis
longus

First dorsal
interosseous muscle

In these examples, notice how when the arm is under tension in the act of grasping an object or bearing weight, the muscles stand out and their tendons show clearly at the inner wrist. When the arm is bent the larger muscles in the upper arm show themselves more clearly and the shoulder muscles and shoulder blades are seen more defined.

125

HANDS

Many people find hands difficult to draw. You will never lack a model here as you can simply draw your own free hand, so keep practising and study it from as many different angles as possible. The arrangement of the fingers and thumb into a fist or a hand with the fingers relaxed and open create very different shapes and it is useful to draw these constantly to get the feel of how they look. There is inevitably a lot of foreshortening in the palm and fingers when the hand is angled towards or away from you.

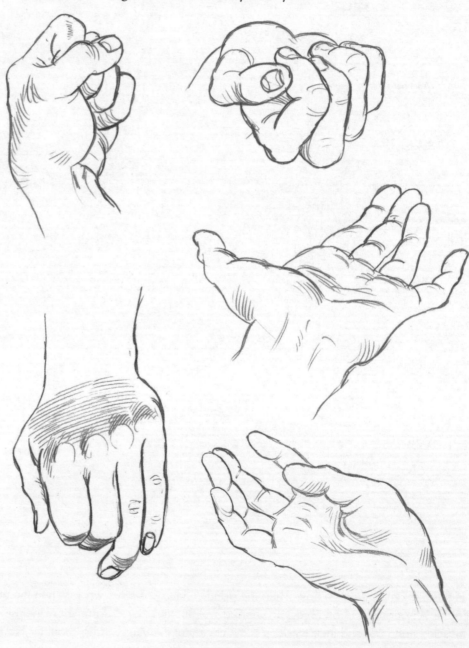

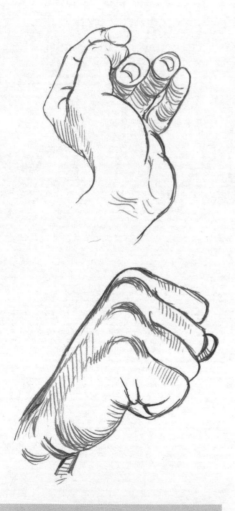

HANDY HINT

The hand is an extremely effective means of conveying emotional and instinctive gestures. As well as providing a focal point, the outstretched arm or hand often provides an important key to a picture.

126

FEET

The feet are not such a familiar part of the body as the arms and hands, as people tend to keep their shoes on when walking about in public. The bone structure of the foot is quite elegant, producing a slender arch over which muscles and tendons are stretched.

The inner ankle bone is higher than the outer, which helps to lend elegance to this slender joint. If the difference in the position of the ankle bones is not noted the ankle becomes a clumsy shape.

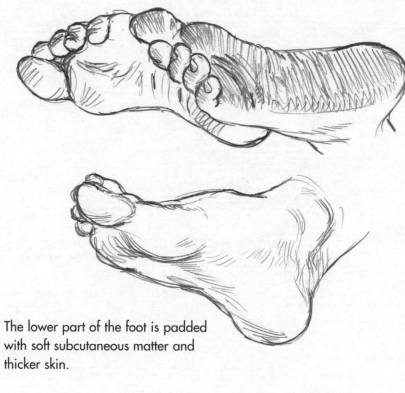

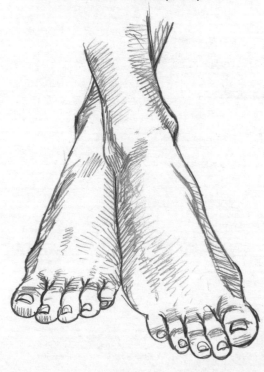

The lower part of the foot is padded with soft subcutaneous matter and thicker skin.

Notice how the toes, unlike the fingers, tend to be more or less aligned, although the smaller toes get tucked up into small rounded lumps.

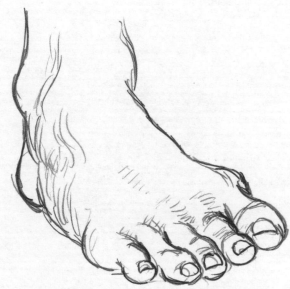

THE HEAD

The head is defined mostly by the shape of the skull underneath its thin layer of muscle, and to a lesser extent by the eyeballs. The flat groups of muscles on the skull produce all our facial expressions, so it is very useful to have some idea of their arrangement and function, especially if you want to draw portraits.

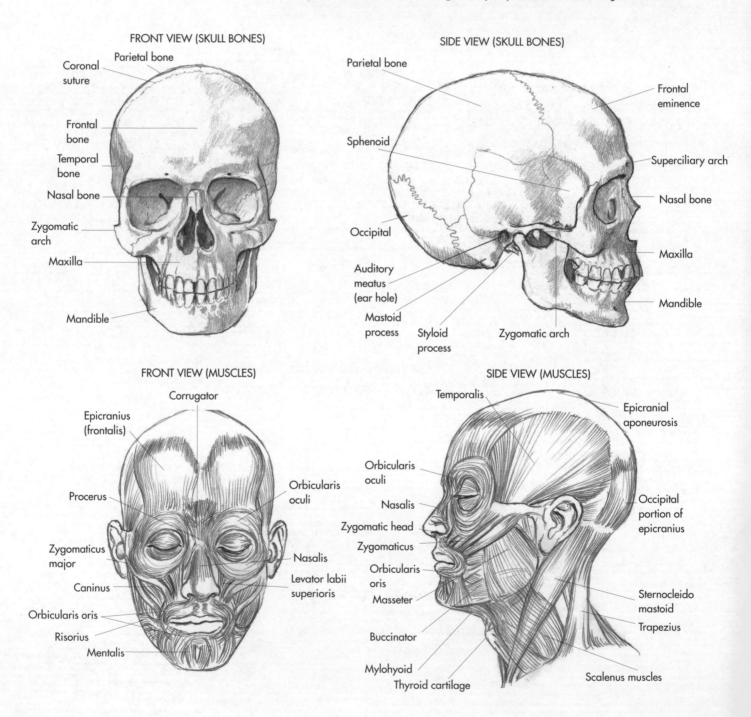

FRONT VIEW (SKULL BONES)

Coronal suture
Parietal bone
Frontal bone
Temporal bone
Nasal bone
Zygomatic arch
Maxilla
Mandible

SIDE VIEW (SKULL BONES)

Parietal bone
Frontal eminence
Sphenoid
Superciliary arch
Nasal bone
Occipital
Maxilla
Auditory meatus (ear hole)
Mastoid process
Styloid process
Zygomatic arch
Mandible

FRONT VIEW (MUSCLES)

Corrugator
Epicranius (frontalis)
Procerus
Orbicularis oculi
Zygomaticus major
Nasalis
Caninus
Levator labii superioris
Orbicularis oris
Risorius
Mentalis

SIDE VIEW (MUSCLES)

Temporalis
Epicranial aponeurosis
Orbicularis oculi
Nasalis
Occipital portion of epicranius
Zygomatic head
Zygomaticus
Orbicularis oris
Masseter
Buccinator
Sternocleido mastoid
Trapezius
Mylohyoid
Thyroid cartilage
Scalenus muscles

The head from different angles

Here I have drawn the head from a variety of different angles. In the main there are no particular details of the face – just the basic structure of the head when seen from above, below and the side. Notice how the line of eyes and mouth curve around the shape of the head. When seen from a low angle, the curve of the eyebrows becomes important, as does that of the cheekbones.

Sometimes the nose appears to be just a small point sticking out from the shape of the head, especially when seen from below. Conversely, when seen from above, the chin and mouth almost disappear but the nose becomes very dominant. From above, the hair becomes very much the main part of the head, whereas when seen from below the hair may be visible only at the sides.

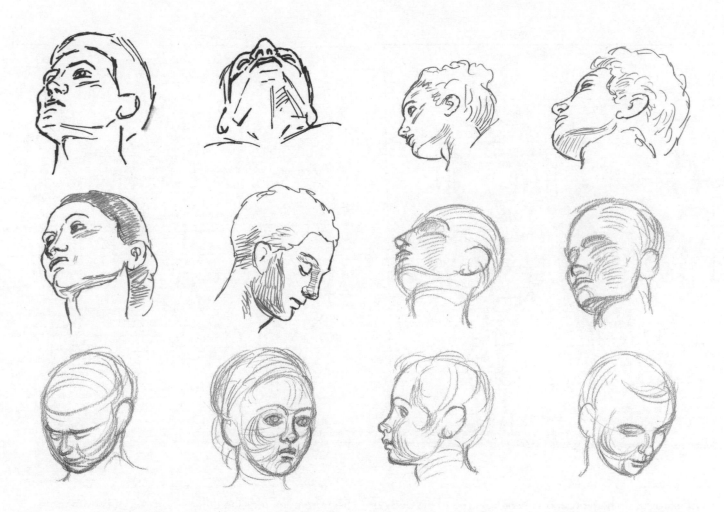

These forms are still a highly simplified form of drawing, but they describe the features very well and look quite realistic. The different viewpoints given of the head are useful to get a fuller idea of how it is formed. Make a practice of drawing the parts of the figure from many angles in order to fix in your mind what it really looks like, then draw exactly what you see as accurately as you can. You will soon start to see your efforts pay off.

DIFFERING PROPORTIONS

People are not alike in form, and few conform to the classical ideal. Once they have grown to full size the basic proportions differ between them very little in the height, but in the shape and width of the body there can be many varying proportions.

Bodies come down to two main types, the thick and the thin. There are some people who put on significant weight as they grow older and others who seem to lose it just as radically. The examples shown here are of the same height and vertical proportion but vastly different in width.

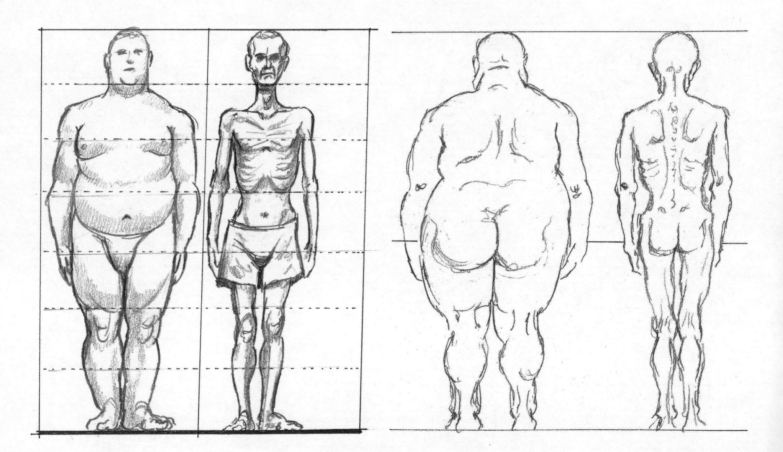

Most extra fat gathers around the central area of the body at the waist, and the upper parts of the legs and arms are often thicker. At the other extreme, when someone is below normal weight, the human frame is reduced to a very meagre stringy-looking type. The width of the torso and limbs is dictated only by the bone structure.

Seen from the rear the difference in width is even more extreme, with one being widest at the centre while the more skeletal figure is widest at the shoulders. It is interesting to note this sort of difference in figures, although probably not many are as extreme as these.

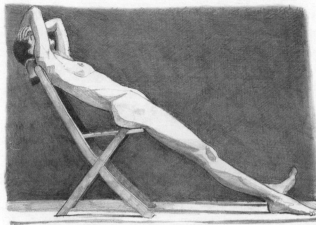

This copy of a painting by Euan Uglow relies on the extremely slim proportions of the model to emphasize the dramatic, diagonal, downward thrust of the composition, broken only by her upturned foot in the bottom right-hand corner.

HANDY HINT

Beginners tend to draw what they think people should look like, and will even change a figure to make it fit their preconceptions. Often they will slim down a fat model or fatten up a thin one. This does not result in accurate draughtsmanship and has to be eliminated if progress is to be made.

This drawing, based on a painting by Lucian Freud, is of a very large woman with well-developed breasts and belly, and big, fleshy thighs and arms. She is sitting, so the full proportion is less easy to see.

COMPOSITION AND POSING

When you first begin to study figure drawing your aim is to draw the model from a range of viewpoints as you build up your understanding of how the human body looks. The information and experience you gain by doing this is of enormous help to the development of the artistic skills necessary to cope with drawing the figure.

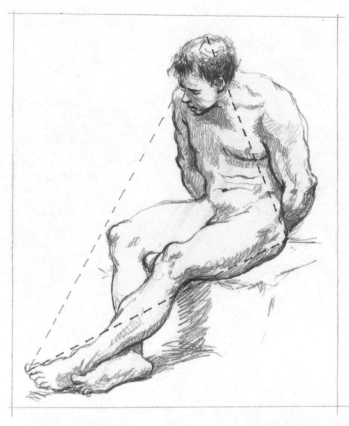

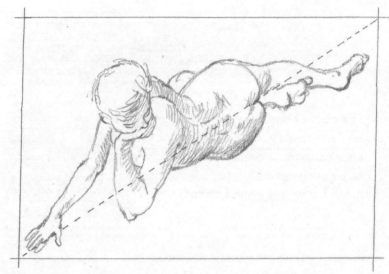

Here the edges of the frame are placed so that the figure appears to stretch from the upper right-hand corner to the lower left-hand corner. The centre of the picture is taken up by the torso and hips and the figure is just about balanced between the upper and lower parts of the diagonal line. You will find that it is quite often the spaces left by the figures that help to define the dynamics of your picture and create drama and interest.

This seated man with his hands behind his back, based on a drawing by Natoire in the Louvre, fits into an elongated triangle. The bulk of his body is between the sides of the triangle, and because the emphasis is on the stretch of his legs to the bottom left-hand corner of the picture there is a strong dynamic that suggests he is under some duress – perhaps a prisoner.

HANDY HINT

Looking for simple geometric shapes such as triangles and squares will help you to see the overall form of the figure and achieve a cohesive composition within your format.

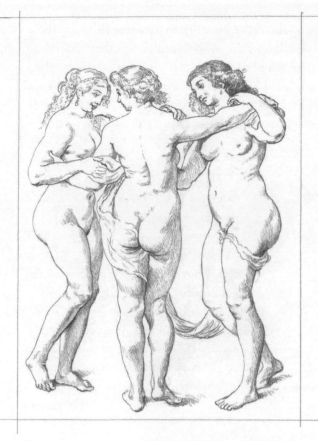

For an example of a three-figure composition I have drawn *The Three Graces* by Peter Paul Rubens, the great master painter of Flanders. He posed his models in the traditional dance of the Graces, hands intertwined. Their stances create a definite depth of space, with a rhythm across the picture helped by the flimsy piece of drapery used as a connecting device. The flow of the arms as they embrace each other also acts as a lateral movement across the picture, so although these are three upright figures, the movement across the picture is very evident. The spaces between the women seem well articulated, partly due to their sturdy limbs.

I based this drawing on Botticelli's picture *Venus and Mars*, which can be seen in London's National Gallery, in which the reclining figure of Mars is totally surrendered to sleep. As a reclining figure it is one of the most relaxed-looking examples of a human figure.

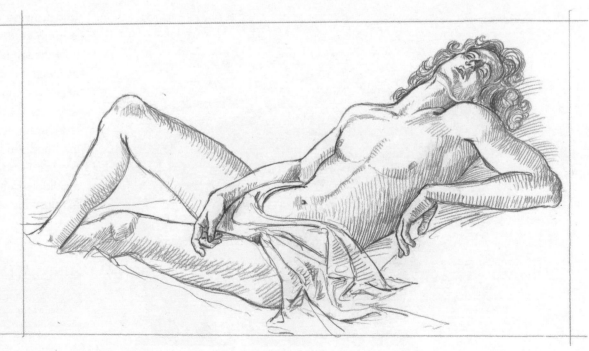

MOVING FIGURES

Photographs are a great boon to the artist wanting to discover just how the parts of the body relate to each other as the model moves, but they should be used with caution as copying from a photograph can produce sterile results. An artist should be looking not just to make an accurate drawing of lines and shapes but also to express the feeling of the occasion in a way that the viewer will understand: look particularly at the styles of depiction chosen here.

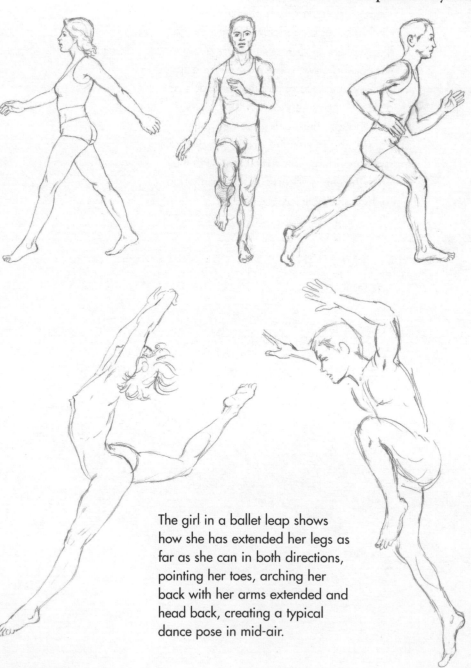

The figures shown here are quite precisely based on photographs of people walking and running. A photograph gives you one particular moment in the action and because you can draw it with a precise line, given the benefit of a still image from which to copy, the final result tends to look slightly formalized. This produces a certain stiffness in the drawing which you can overcome by more direct experience.

This drawing of a leaping man shows how the left leg is bent as much as possible while the right leg is extended. The torso is leaning forward, as is the head, and the arms are lifted above the shoulders to help increase his elevation.

The girl in a ballet leap shows how she has extended her legs as far as she can in both directions, pointing her toes, arching her back with her arms extended and head back, creating a typical dance pose in mid-air.

HANDY HINT

Notice how the pencil marks can be made to reflect the energy and sense of urgency in the subject matter.

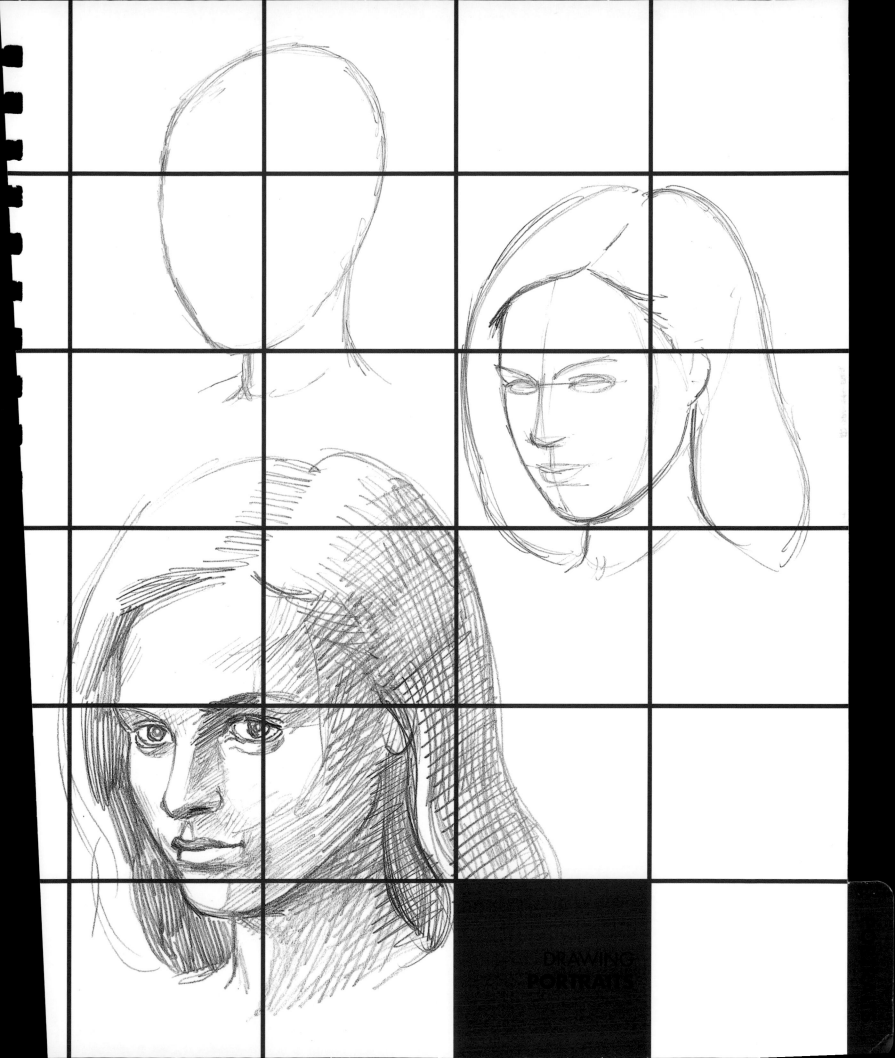

INTRODUCTION

What is a portrait? It is said that Picasso produced a Cubist portrait of a friend and when this was shown to Matisse he could not identify the person. Picasso then stuck a moustache on to the picture and Matisse could immediately see the likeness. This story exemplifies a fundamental aspect of portraiture: no matter how far from an exact likeness a drawing may be, it must contain some recognizable form of the person. In order to capture this you will need to spend a lot of time in direct observation, noting the particular image of a human being that your subject represents.

How much you should flatter or be brutally honest with your subject when drawing is a perennial question. If they, like Cromwell, want a portrait 'warts and all' then the more objective you can be the better. However, very few people are honest enough about their own appearance to be able to live with the consequences of this approach, and so most portrait artists try to give the best possible view of the sitter. This may mean altering the light effects, changing the position of the head slightly, getting the sitter to relax, and employing other small ways of helping to ease tension out of the face and bring some agreeable element into prominence. Fortunately, most people have some good feature that can be the focal point of a portrait, allowing the artist to slightly reduce the importance of a tense mouth, a weak chin or rather protruding ears or nose. The ravages of time have also to be taken into account, although lines, creases or sagging flesh can be slightly softened to give a more acceptable version which is still recognizable.

Throughout this section you will find a range of approaches and valuable lessons to absorb and learn from. There is not a portrait in the pages that follow that cannot teach us something about the way to approach depicting the features of friends, family, acquaintances and even complete strangers. What I hope you will also come to realize is that although the measurable differences between all the faces portrayed are really very minute, the appearances are immensely varied. The human face has an extraordinary ability to show a whole range of expressions and emotions. It is this facility which artists have striven for generations to explore in myriad ways.

What comes out of this exploration does, of course, depend on the skill of the artist. The only way to reach the level of skill required to produce good portraits is to practise drawing. The more you practise, the better you will get. If you cannot regularly practise drawing faces, any type of drawing is a valid way to increase your skills. Change the situation, the lighting and the surroundings and you will have a different portrait. This is why so many artists find portraiture endlessly fascinating. There really is no limit to the possibilities for expression it offers.

Barrington Barber

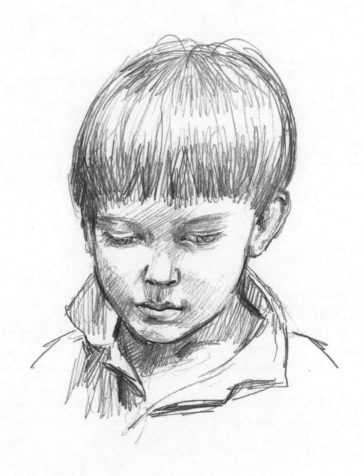

PROPORTIONS OF THE HEAD

For beginners especially it can be very helpful to use a grid as a guide on which to map out the head in order to ensure that the proportions are correct. Those shown here are broadly true of all adult humans from any part of the world, and so can be applied to anyone you care to use as a model. The head must be straight and upright, either full face or fully in profile. If the head is at an angle the proportions will distort.

For these two full-face examples, a proportion of five units across and seven units down has been used. Note the central line drawn vertically down the length of the face. This passes at equidistance between the eyes, and centrally through the nose, mouth and chin.

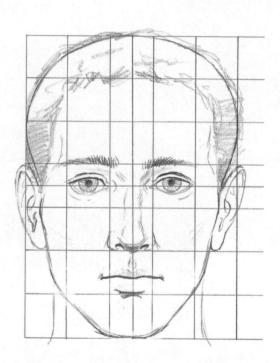

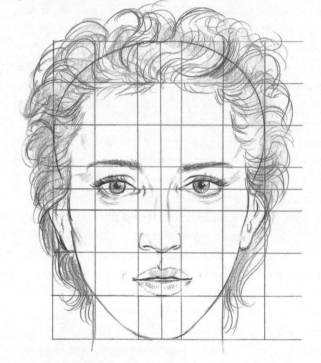

Horizontal Reading: Full Face

- The width of the eye is one-fifth of the width of the whole head and is equal to 1 unit.
- The edge of the head to the outside corner of the eye is 1 unit.
- The inside corner of the left eye to the inside corner of the right eye is 1 unit.

Vertical Reading: Full Face

- Eyes: halfway down the length of the head.
- Hairline: 1 unit from the top of the head.
- Nose: 1½ units from the level of the eyes downwards.
- Bottom of the lower lip: 1 unit up from the edge of the jawbone.
- Ears: the length of the nose plus the distance from the eye-line to the eyebrows – 2 units.

136

For easy comparison, these two profile examples have been drawn to exactly the same size as those on the preceding page. The head in profile is 7 units wide and 7 units long, including the nose.

Do not forget that the human head is different in each individual. These grids will help you to look at the distances between features, but it is your observational skills that will be needed to create a likeness.

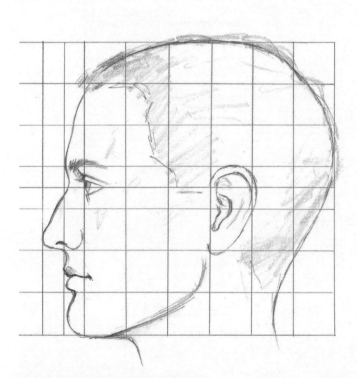

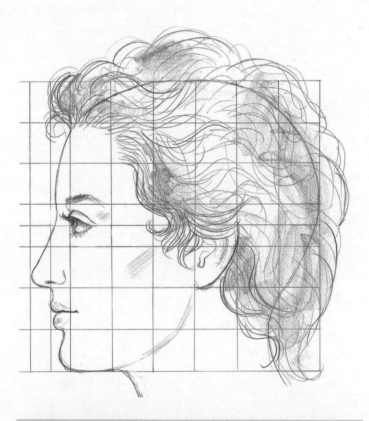

Horizontal Reading: Profile

- The front edge of the eye is 1 unit back from the point of the nose.
- The ear is 1 unit in width. Its front edge is 4 units from the point of the nose and 3 units from the back edge of the head.
- The nose projects half a unit from the front of the main skull shape.

HANDY HINT

It is important to remember that while the female head is generally smaller than the male, the proportions are exactly the same. See page 140 for information on the head proportions of children, which at certain ages are significantly different from those of adults.

MEASURING THE HEAD

The surest way of increasing your understanding of the head, and becoming adept at portraying its features accurately, is to practise drawing it life size, from life. It is very difficult to draw the head in miniature without first having gained adequate experience of drawing it at exactly the size it is in reality, but this is what beginner artists tend to do, in the mistaken belief that somehow it will be easier.

Getting to know the head involves mapping it out, and this means measuring the distances between clearly defined points. For the next exercise you will need a live model, a measuring device, such as a ruler or callipers, a pencil and a large sheet of paper.

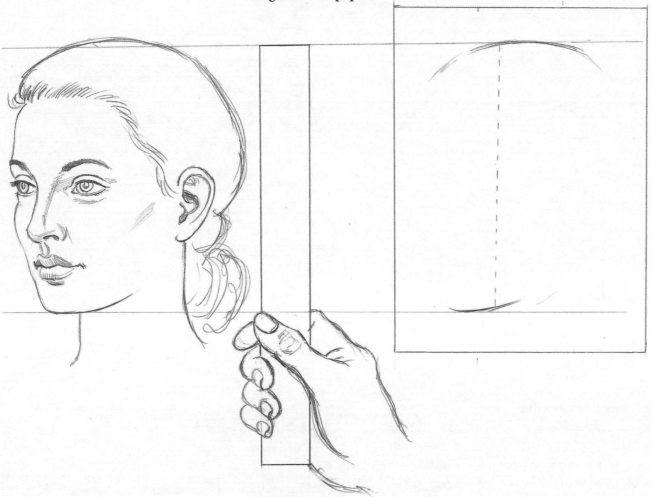

Measure the length of the head from the highest point to the tip of the chin. Mark your measurement on the paper. Measure the width of the head at the widest point; this is usually across the area just above the ears, certainly if viewed full on from the front. Mark this measurement on the paper. The whole head should fit inside the vertical and horizontal measurements that you have transferred to your drawing paper.

Measure the eye level. This should be about halfway down the full length of the vertical, unless the head is tilted. Decide the angle you are going to look at the head. Assuming it is a three-quarter view, the next measurement is critical: it is the distance from the centre between the eyes to the front edge of the ear.

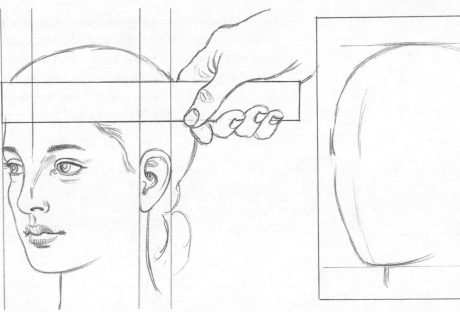

Measure the distance from the outside edge of the nostril to the front edge of the ear. Mark it and then place the shape of the ear and the position of both eyes. Check the actual length of the nose from the inside corner of the eye down to the base of the nostril. Next measure the line of the centre of the mouth's opening; you can calculate this either from the base of the nose or from the point of the chin. Mark it in. Now measure from the corner of the mouth facing you to a line projecting down the jawbone under the ear. Mark that too.

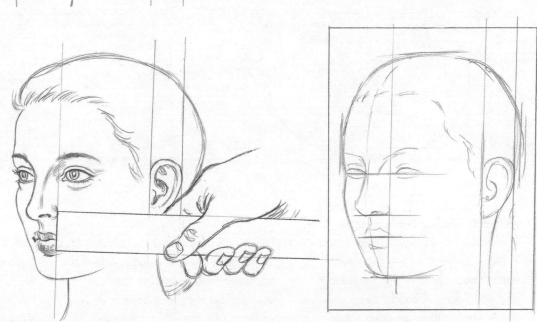

<div style="background:grey">

HANDY HINT

It is important to draw the shape of the head and the position of the features from different angles, as the appearance can differ radically.

</div>

THE PROPORTIONS OF CHILDREN

There are significant proportional differences between children and adults which the artist has to bear in mind when undertaking a portrait. One of the most obvious is seen in the head, which in an adult is about twice as large as that of a two-year-old. The features, too, change with growth. In adults the eyes are closer together and are set halfway down the head. Nose, cheekbones and jaw become more clearly defined and more angular as we mature.

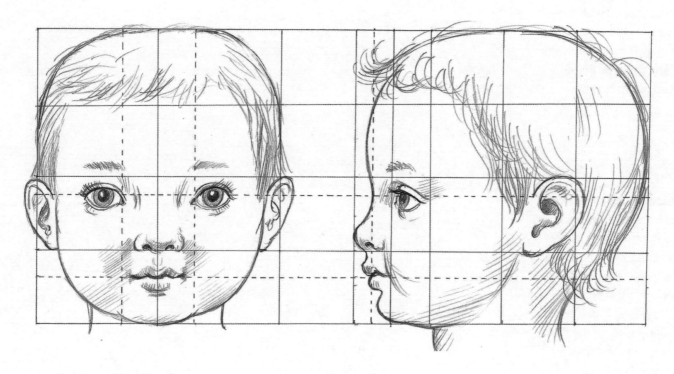

The Head: Major Differences

- In relation to its body, a child's head is much larger; this will be evident even if you can only see the head and shoulders. A child's head is much smaller than an adult's, but the proportion of head to body is such that the head appears larger.
- The cranium or upper part of the child's skull is much larger in proportion to the rest of the face. This gradually alters as the child grows and reaches adult proportions.

- The child's eyes appear much larger in the head than an adult's, whereas the mouth and nose often appear smaller. The eyes also appear to be wider apart. The nose is usually short with nostrils facing outward so that it appears upturned. This is because the nasal bones are not developed.
- The jawbones and teeth are much smaller in proportion to the rest of the head, again because they are still not fully developed. The rule

with the adult – that places the eyes halfway down the head – does not work with a child, where the eyes appear much lower down.
- With very young children, the forehead is high and wide, the ears and eyes very large, the nose small and upturned, the cheeks full and round and the mouth and jaw very small.
- The hair is finer, even if luxuriant, and so tends to show the head shape much more clearly.

An exercise in steps

Capturing the likeness of a subject can be problematical, as can choosing the position from which to draw the face. This position gives some idea of the kind of person you are drawing. Aggressive people look up or straight ahead, chin raised. Gentler people tend to look down, as with this young model. Let us take a step-by-step look at drawing him.

Step 1

Before you start, look at the shape of the head as a whole. Study it; it is essential that you get this right.

Now draw an outline, marking the area of hair and the position of the eyes, nose and mouth.

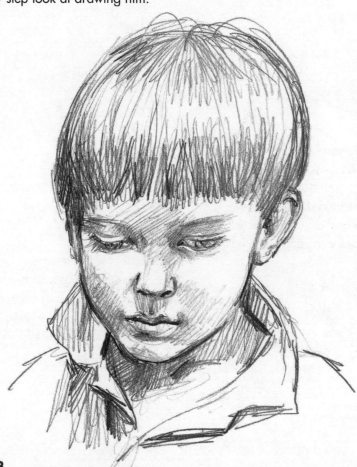

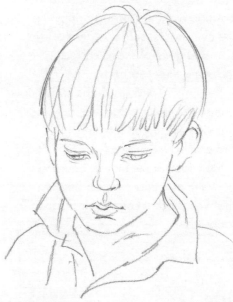

Step 2

Build up the shapes of the ears, eyes, nose, mouth and a few more details such as the hair and neck.

Step 3

In the final drawing, effort has gone into the areas of tone or shadow, the quality of hair and shirt and the tonal variations of the shading around the eyes, nose and mouth in order to define the features. You will notice that the lines of tone go in various directions. There is no single, 'right' way of doing this. In your own drawings you can try out single direction toning, multi-direction toning, shading around and in line with the contours and, where appropriate, smudging or softening the shading until it becomes a soft grey tone instead of lines. What you do – and what you think works – is simply a matter of what effect you wish to achieve. Softer, smoother tones give a photographic effect, while more vigorous lines inject liveliness.

DRAWING THE HEAD: BASIC METHOD

As on the previous pages, the basic shapes and areas of the head have to be taken into account when you start to draw any portrait. In the exercise below I cover five basic steps. These will give you a strong shape which you can then work over to get the subtle individual shapes and marks that will make your drawing a realistic representation of the person you are drawing.

Step 1

Ascertain the overall shape of the head or skull and the way it sits on the neck. It may be very rounded, long and thin or square and solid. Defining the shape clearly and accurately at the outset will make everything else easier later on.

Step 2

Decide how the hair covers the head and how much there is in relation to the whole head. Draw the basic shape and do not concern yourself with details at this stage.

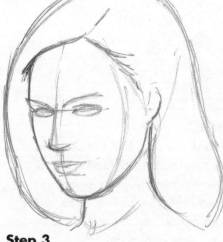

Step 3

Now ascertain the basic shape and position of the features, starting with the eyes. Make sure you get the level, size and general shape correct, including the eyebrows.

The nose is next, its shape (whether upturned, straight, aquiline, broad or narrow), its tilt and the amount it projects from the face.

Now look at the mouth, gauging its width and thickness, and ensure that you place it correctly in relation to the chin.

Step 4

The form of the face is shown by the tonal qualities of the shadows on the head. Just outline the form and concentrate on capturing the general area correctly.

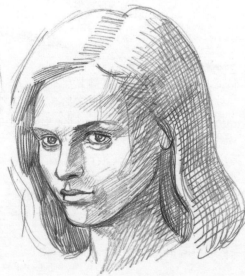

Step 5

Work in the tonal values over the whole head, noting which areas are darker and which are not so dark, emphasizing the former and softening the latter.

DRAWING THE HEAD: ADVANCED METHOD

An alternative method is to work from the centre of the features and move outwards toward the edges. Start by drawing a vertical line down the middle of your paper and then make a mark at the top and bottom of it. Now follow the steps shown here. Look carefully at your model throughout the exercise.

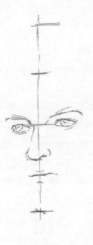

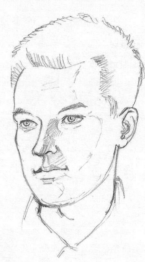

Step 1
Mark a horizontal line for the position of the eyes, halfway between your top and bottom marks. Roughly mark in the relative position and shapes of the eyes.

Step 2
Draw in the shapes of the eyes and eyebrows more fully. Notice how the eye nearest to you is seen more full on than the eye further away. Try to define the point where the further eyebrow meets the edge of the head as seen from your position.

Step 3
Trace out the shape of the shadows running down the side of the head facing you. Do not make the lines too heavy.

Step 4
Begin by darkening the areas that stand out most clearly. Carefully model the tone around the form – especially the side of the nose and the top lip, for example – so that where there is a strong contrast you increase the darkness of the tone and where there is less contrast you soften it, even rubbing it out if necessary. Build up the tonal values with care, ensuring that in the areas where there is a gradual shift from dark to light you reflect this in the way you apply tone.

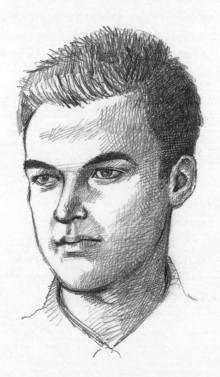

HANDY HINT
Always try to reproduce exactly what you see in front of you, and not what you do not see. Trust your eyes – they are very accurate.

143

THE FEATURES CLOSE UP

EYES

Seen in profile, the eye is a simple shape to draw..

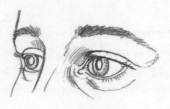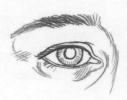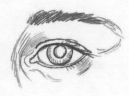

Profile view

The eyelids should project beyond the curve of the eyeball: if they did not project, the eye could not close.

Three-quarter view

Note a marked difference in the shapes. The further eye is closer to the profile view in that the eyelid projects past the eyeball on the outside corner. On the nearer eye, because the inside corner is visible, the shape appears to be more complete. The far eyebrow appears shorter than the near one.

Frontal view

From this angle the eyes are more or less a mirror image. The space between them is the same as the horizontal length of the eye. Note that normally about one-eighth to one-quarter of the iris is hidden under the upper eyelid, and the bottom edge just touches the lower lid.

NOSE

The nose at different angles presents marked differences in shape. In very young people the nostrils are the only areas that stand out.

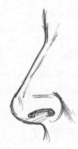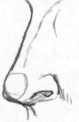

Profile view

The main observation here concerns the shape of the nostril and its relationship to the point of the nose.

Three-quarter view

The outline shape is still evident but notice how its relationship to the nostril has changed.

Frontal view

The only shapes visible are the surface of the length of the nose and the point. The nostrils are the most clearly defined areas, so note their relationship.

MOUTH
Profile view

The line of the mouth (where the lips part) is at its shortest in this view. Note whether the upper lip projects further than the lower lip, or vice versa, or whether they project similarly.

Three-quarter view

The angle accounts for the difference in the curves of top and bottom lip. The nearer side appears almost as it does straight on, whereas the farther side is shortened due to the angle.

Frontal view

This view is the one we are most familiar with. The line of the mouth is very important to draw accurately – you need to capture its shape precisely or the lips will not look right.

The angle of the eyes as they appear in relation to each other –

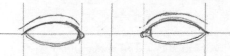

Do they look straight across from corner to corner?

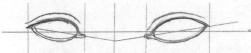

Do the inner corners look lower than the outer corners?

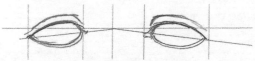

Do the outer corners look lower than the inner corners?

The measurements you have taken in the previous exercises will provide accurate proportions for you to work to when drawing the features. When you have sketched out roughly where every feature begins and ends, look carefully at the shapes of each of them and then draw them in.

The eyes are often what makes a person recognizable to us; the mouth and nose are next. The rest depends on the characteristics of your subject. The illustrations on this page show the main points and relationships to consider when drawing the features.

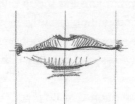

The curve of the mouth – Is it dead straight? … up? … down?

LIPS
Are they thin or generous?

The eyelids
Are they narrow or broad?

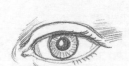 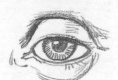

The eyebrows
Are they curved or straight?

HANDY HINT

Remember to look at the hairline since getting this right can make a big difference to your likeness – is it straight or uneven?

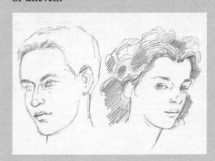

EARS
These come in a variety of permutations; here are a few for you to consider.

SETTING UP A PORTRAIT

When you are confident of your ability to draw the features accurately, you are ready to try your hand at a full-scale portrait. Someone may commission you to draw a portrait, but it is more likely you will have to initiate the event yourself, especially in the beginning.

You will need to agree on a number of sittings with your model, and how long each of these should last; two or three sittings of between 30 minutes and one hour should be sufficient. It is advisable not to let your subject get too bored with sitting, because dullness may creep into their expression and into your portrait.

Once the schedule has been decided, it is time to start work. First, make several drawings of your subject's face and head, plus the rest of the body if that is required, from several different angles. Aim to capture the shape and form clearly and unambiguously. In addition, take photographs: front and three-quarter views and possibly also a profile view.

All this information is to help you decide which is the best view, and just how much of your subject's figure you want to show. The preliminary sketching will also help you to get the feel of how their features appear, and shape your ideas of what you want to bring out in the finished work. Alterations in natural lighting conditions and changing expressions will give subtle variations to each feature. You have to decide exactly which of these variations to include in the drawing.

HANDY HINT

Decide on the pose. If you choose to put your model in a chair, or incorporate some other prop, include the chair or prop in your sketches. See pages 154–7 for more on designing a composition and posing.

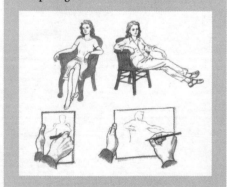

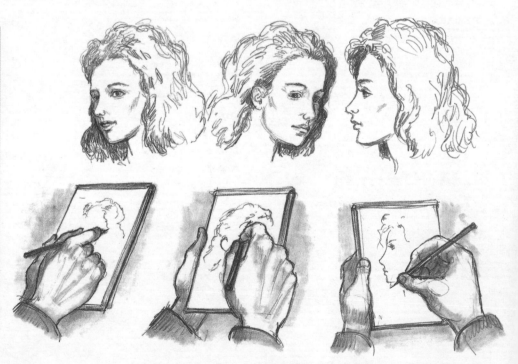

Draw the face from left and right and also in profile.

Rule of thumb

When drawing at sight size – the size a figure or object looks from where you are standing – the proportions can be gauged by using the rule of thumb method. Take the measurement by holding your arm outstretched with your pencil upright in line with the drawing board (see illustration below). Once the measurement has been taken, you can then transfer it to your drawing paper.

You must ensure that you measure everything in your drawing in the same way, keeping the same distance from your model and your pencil extended at arm's length. If you do this, the method will give you a fairly accurate range of proportions. Deviate from this, however, and you will find your proportions looking decidedly out of kilter.

The rule of thumb method can also be used when drawing larger than sight size, by extrapolating from the proportions. However, only experienced artists should attempt this. For those in the early stages of learning to draw it is always helpful and instructive to draw much larger than rule of thumb allows, preferably at larger than life size, so that mistakes can be seen clearly and the necessary corrections made.

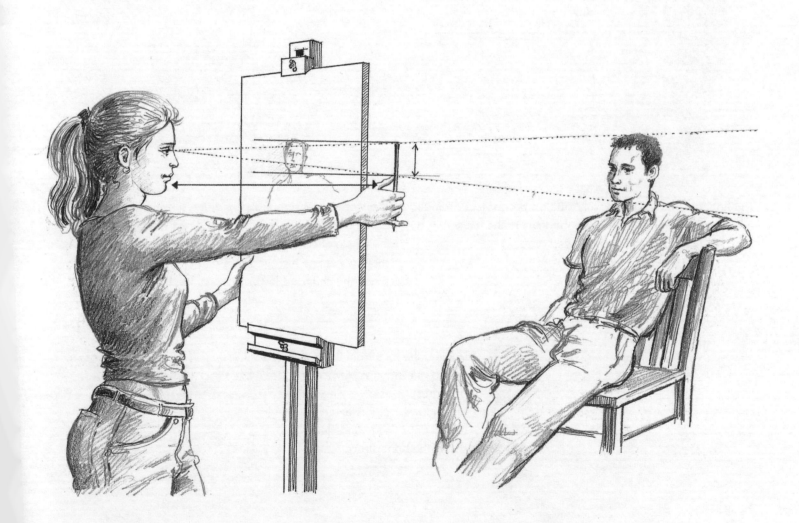

LIGHTING YOUR SUBJECT

Any portrait will be affected by the sort of lighting used, whether natural or artificial. The artist Ingres described the classical mode of lighting as 'illuminating the model from an almost frontal direction, slightly above and slightly to the side of the model's head'. This approach has great merit, especially for beginners in portraiture, because it gives a clear view of the face but also allows you to see the modelling along the side of the head and the nose, so that the features show up clearly.

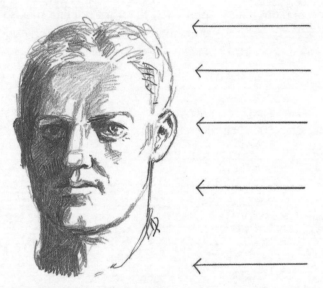

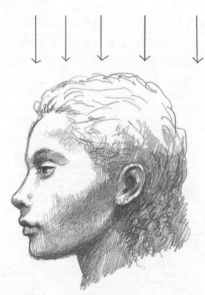

The light coming from precisely side on produces a dramatic effect, with strong, well-marked shadows to the left giving a sharp-edged effect to the shadowed area.

The three-dimensional aspect of the girl's head is made very obvious by lighting coming from directly above, although the whole effect is softer than in the previous example. The shadows define the eyebrows and cheekbones and gently soften the chin and lower areas of the head.

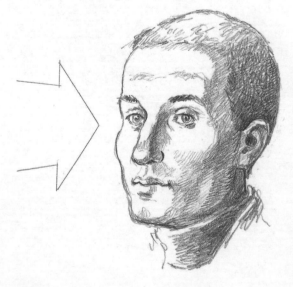

Lighting the face from the front and to one side (as advocated by Ingres) gives a very even set of shadows – in this example on the right side – and clearly shows the bone structure.

HANDY HINT

As this series of images shows, directional lighting can make an immense difference to a face. The same principles apply equally to figures and objects. Experiment for yourself, using a small lamp or candles. Place objects or a subject at various angles and distances from a light source and note the difference this makes.

With artificial lighting, you can control the direction and amount of light and you are not dependent on the vagaries of the weather. To achieve satisfactory results, several anglepoise lamps and large white sheets of paper to reflect light will do.

Lighting from behind the subject has to be handled very carefully; while it can produce very subtle shadows, there is a danger of ending up with a silhouette if the light is too strong. Usually some sort of reflection from another direction creates more interesting definitions of the forms.

The only directional lighting that is not very useful is lighting from beneath the face, because light from below makes the face unrecognizable.

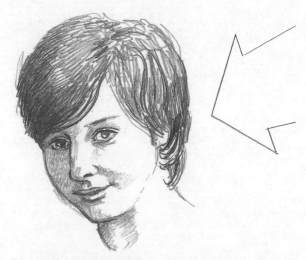

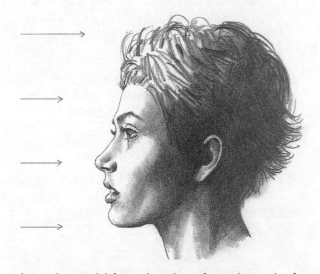

Lit frontally and from above, this example also owes a debt to Ingres. The slight tilt of the head allows the shadows to spread softly across the far side of the face.

Lighting the model from directly in front shows the features strongly, while areas of the hair and the back of the head are left in deep shadow.

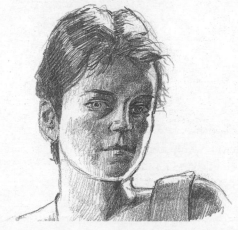

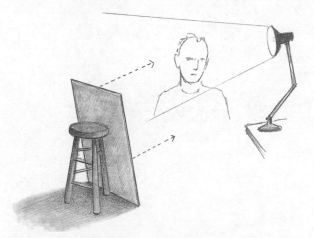

Lighting from behind is not usual in portraiture, although it has been done quite effectively. The trick is to be careful not to overdo it.

Reflected light can be used to flatten out too many shadows cast over the face. If you want to try this, place a large white sheet of card or similar opposite your light source.

STYLES

On the following pages are examples of portraits using the different techniques we have looked at. Some are more finished than others, but they all have a unique style and capture something of the character of the sitter.

The details of the face are simplified and most of the tonal values dispensed with in this copy of a drawing of Aristide Maillol by fellow sculptor Eric Gill. The different emphasis in the outlines helps to give an effect of dimension, but it is more like the dimension of a bas-relief sculpture.

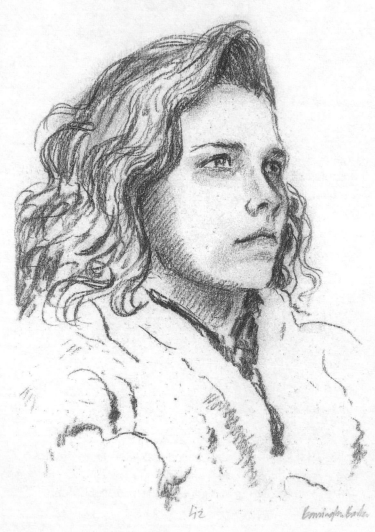

This black chalk drawing on a tinted paper took about twenty minutes. The style is fairly simple and the technique quite easy. The face has been drawn in without much modelling and with the emphasis on placing the features correctly. Interest has been created by the texture of the chalk line and the model's attractive longish hair.

The most time-consuming aspect of this pen and ink drawing (fountain pen with a fine point on fairly thin paper) was tracing out the profile. The drawing had to be done quickly because the model was only available for a few minutes, being part of a class of art students sitting for one another. The outline was the main point of emphasis, with a bit of tone, especially on the hair. It is important with quick drawings to concentrate on one aspect and not try to be too clever.

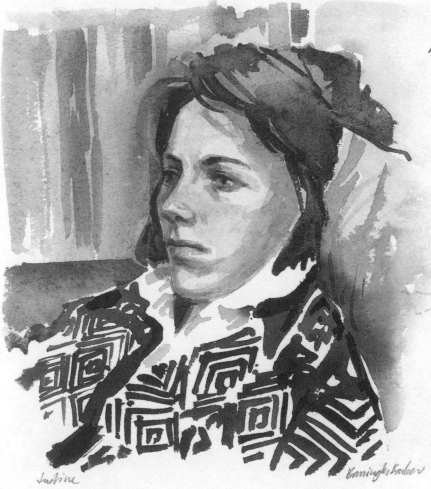

Justine

Kamingh Barbar

Plenty of water has been used to keep the tones on the face and the background soft in this example of watercolour on watercolour paper. The strength of colour on the jacket and hair is greater than elsewhere in the picture. The eyes, nose and mouth need touches of strong tone, especially the line of the mouth and the upper eyelashes, eyebrows and pupils of the eyes. This type of drawing can be built up quite satisfactorily, with the lighter tones put in first all over and then strengthened with the darks.

The most dimension is achieved for the least effort in this example. The reason is the use of three materials in combination: brown and terracotta conté pencil, white chalk and toned paper. Notice how the strong emphasis provided by the darker of the conté pencils is kept to a minimum, sufficient to describe what is there but no more. Similarly the chalk is used only for the strongest highlights. The mid-tone is applied very softly, with no area emphasized over-much. The toned paper does much of the artist's work, enabling rapid production of a drawing but one with all the qualities of a detailed study. Often you will find it effective to include some background to set off the lighter side of the head.

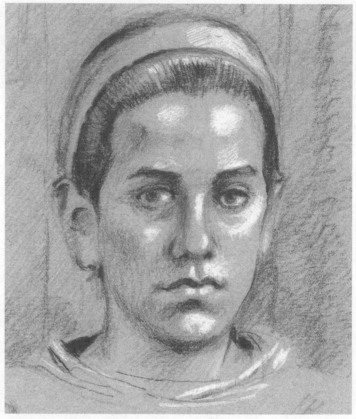

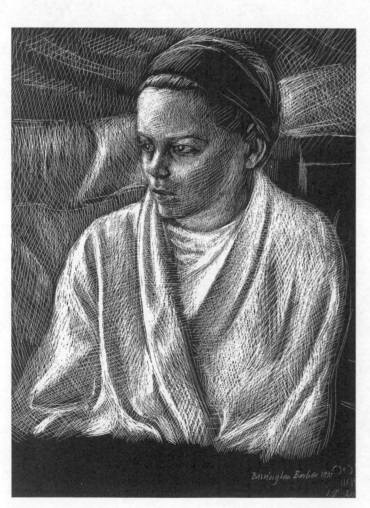

With scraperboard technique the artist has to draw back-to-front, revealing all the light areas and leaving the dark ones. This subject was ideal, her white bath-robe ensuring there were plenty of light areas, although it was difficult to judge how much to work the face. The hair and hairband were made up of dark tones, and so required only the addition of highlights.

HANDY HINT

Similar effects to scraperboard can be obtained with white chalk on black paper. Try it as an exercise; it will teach you a great deal about gauging the balance of light and dark.

A range of coloured felt-tip pen was used for this spontaneous drawing, hence the variation in tonal effect. Felt-tip is a fairly coarse medium, so I was careful to leave space between the lines except in the outline.

An ordinary fountain pen with a fine nib was used to produce this quick sketch. The technique is almost scribbly because only a few minutes were available to get the drawing down. The tonal areas had to be put in very simply with the dark areas gone over repeatedly to give them sufficient emphasis. The contrast between the dark areas and the uncovered areas is important for the dimension in the drawing.

153

COMPOSITION

Here we look at examples of composition from two undoubted contemporary masters of portraiture, David Hockney and Lucian Freud. While Hockney has chosen to borrow from past conventions, Freud has more obviously struck out on his own. Both approaches make us either question the situation or provoke our curiosity, either of which is a good response to any portrait.

David Hockney's ability to echo the fashionable colour schemes of modern life in his work made him an obvious choice as portraitist of a fashion designer. In this copy, Ossie Clarke, his wife Celia Birtwell and their cat, Percy, are shown at home in their flat. The positioning of the figures is formal, almost classical, accentuated by the very dark dress worn by Celia and the dark legs of Clarke himself with Percy, outstanding in white, making three. There is minimal furniture, which might be as it was or because the artist arranged it that way. The position of both flowers and the cat is interesting in relation to the main subjects. The shadowed walls adjacent to the bright slot of the window give both space and a dramatic tonality which contrasts well with the two figures.

In Lucian Freud's double portrait of himself and his wife in a Parisian hotel bedroom the poses are as informal as the situation is ambiguous. Why is she in bed and he standing by the window? Obviously he needed to be upright in order to produce the portrait but he has not shown us that he is the artist. There is no camera, sketchbook or easel and brushes in his hands. So what could be his intention? In the hands of a first-class artist this unusual approach has become a ground-breaking idea. The slightly accidental look of the composition is very much of the period in which it was painted (the 1950s).

HANDY HINT

Do not expect your own subjects to hold the pose for long periods, especially when children are involved. You will not be in the same position as Caravaggio, the great Italian painter of groups of figures, who, at the height of his fame, paid his models so well that they would pose for him for days on end.

GROUPING FIGURES

All sorts of arrangements can make good compositions, and in the process tell us a great deal about the sitters. Most artists are interested in incorporating subtle hints about the nature of the relationships between the subjects in the groups they portray. You may choose to introduce an object into your arrangement as a device to link your subjects.

There are many ways of making a group cohere in the mind and eye of the viewer. In this example, again after Lucian Freud, the closeness of the arrangement is integral to the final result. The central interest is shared between the baby and his parents. Our eye travels from the infant to the couple as they support him and each other on the armchair. In front, the elder son is slightly detached but still part of the group. The connection between the

parents and the baby is beautifully caught, and the older boy's forward movement, as though he is getting ready to leave the nest, is a perceptive reading of the family dynamic.

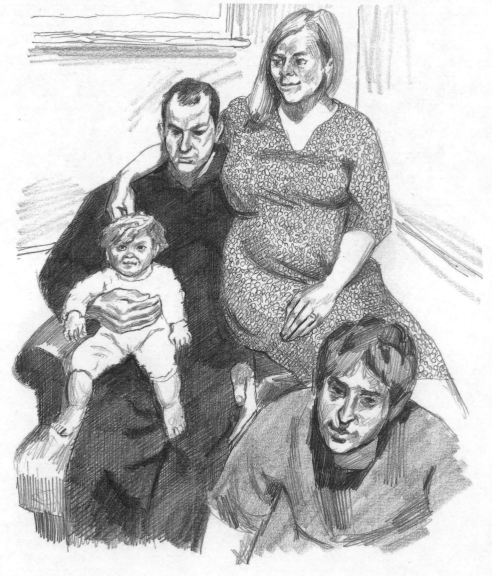

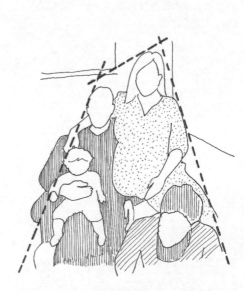

This arrangement makes a very obvious wedge shape leaning to the right. The shape is quite dynamic, but also very stable at the base. The slight lean gives the composition a more spontaneous feel.

This example might almost be a portrait of the car as much as it is of the family. It is the centrepiece of the arrangement, if not quite the head of the household. Pride of possession is very evident among the males. The females inside the car are less obvious, although the mother is in the driving seat. This sort of casually posed arrangement is more often found in photo portraiture.

This composition is unusual and dynamic, partly due to the position of the car. The three figures outside the car form an acute-angled triangle which also gives perspective. The bulge of the car against the longer side of the triangle produces a stabilizing element.

HANDY HINT

The two adult figures and the lifted top of the piano give a stable effect. The curved line that links the position of the heads pulls the eye smoothly across the composition.

Like many 18th-century portraits, this is carefully posed to include clues to the sitters' social position. The artist, Carl Marcus Tuscher, wants to show us that these people are comfortably off – note the care that has gone into the clothing.

The head of the family is Burkat Shudi, a well-known harpsichord manufacturer and friend of the composer Handel. The harpsichord is centrally positioned but set behind. If we were not sure that the family owes its good fortune to the

instrument, Tuscher underlines the connection by posing Shudi at the keyboard. The arrangement is balanced but relaxed.

SELF-PORTRAITS

Artists are their own easiest models, being always available and having no problem about sitting as long as they like. Some artists, such as Rembrandt, have recorded their own faces right up until almost the point of death. Drawing yourself is one of the best ways of training your eye and extending your expertise, because you can be totally honest and experiment in ways that would not be open to you with most other people.

Posing for yourself

The most difficult aspect of self-portraiture is to be able to look at yourself in a mirror and still manage to draw and look at your drawing frequently. What usually happens is that your head gradually moves out of position, unless you have some way of making sure it always comes back to the same point. The easiest way to do this is to make a mark on the mirror, just a dot with felt-tip pen, with which you can align your head each time you look up.

You can only show yourself in one mirror in a few positions because of the need to keep looking at your reflection. Inevitably, the position of the head is limited to full-face or three-quarters so you can still see yourself in the mirror without too much strain. Some artists have tried looking upwards or downwards at their mirrored face but these approaches are fairly rare.

If you want to see yourself more objectively you will have to use two mirrors, one reflecting the image from the other. This way you can get a complete profile view of yourself. This method is worth trying because it enables you to see yourself the right way round instead of reversed as in a single mirror.

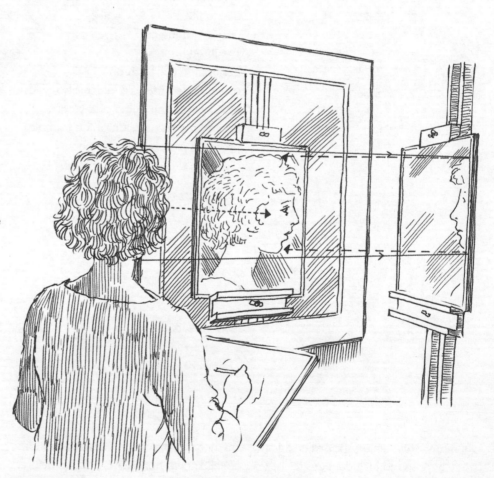

Individual viewpoints

These portraits represent two different stages of Stanley Spencer's career, but despite the distance of 46 years between them both demonstrate the artist's honesty and his lively interest in the visual world he was recording. The younger Spencer is portrayed as a more expectant and confident individual. The second drawing was done in the year of his death and reflects a clear sense of mortality.

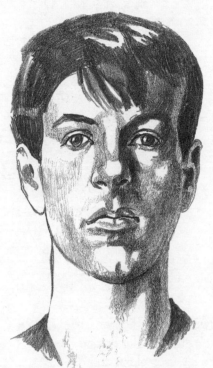

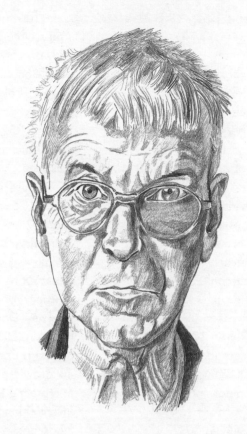

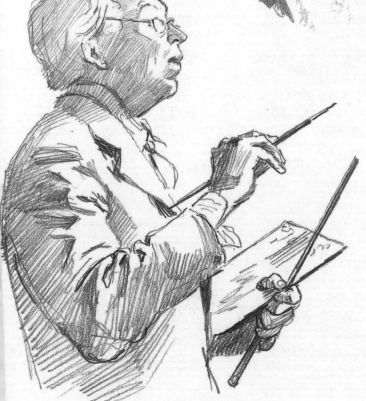

One of the most famous of 20th-century British figurative artists, John Ward has chosen to portray himself in profile for this self-portrait, made in 1983. He has found a brilliant way of conveying vivid animation and a business-like approach through the pose (the balance of the poised brush and palette, the half-glasses perched on the nose, like Chardin) and the dress (formal jacket and tie).

INDEX